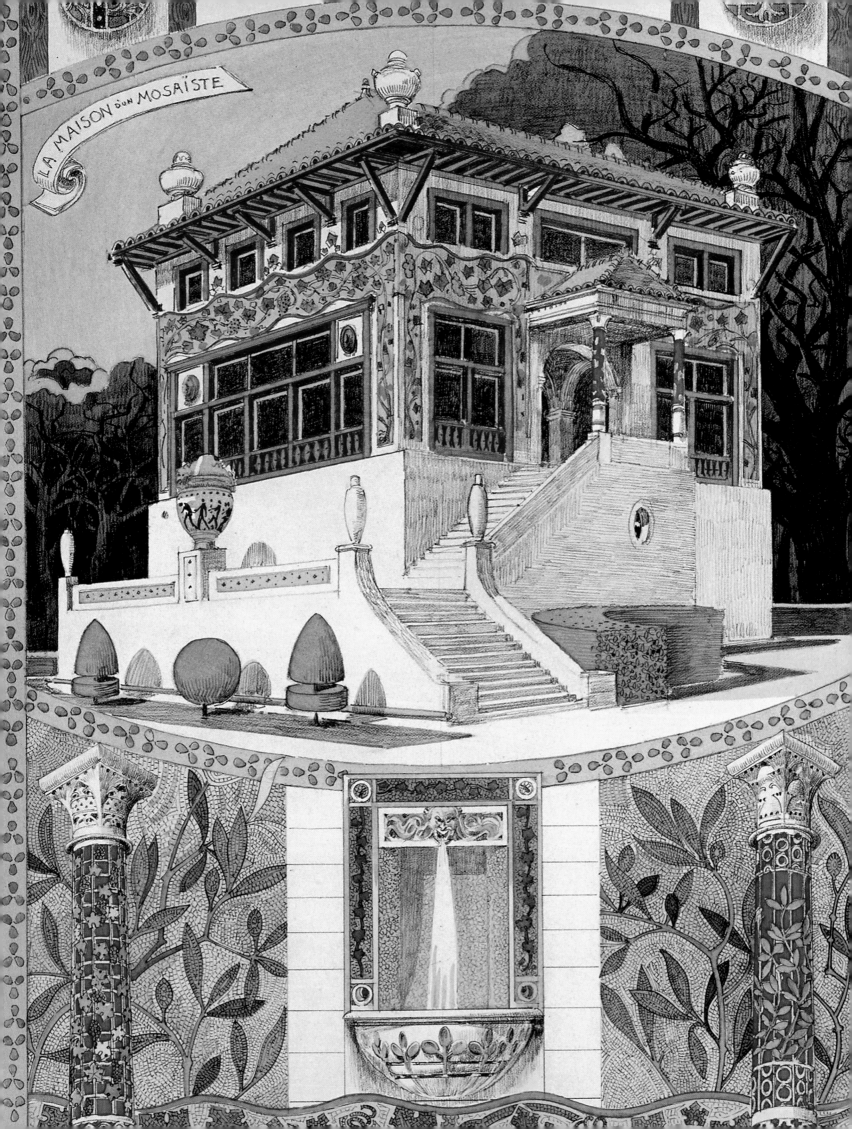

LA MAISON D'UN MOSAÏSTE

René Binet From Nature to Form

With Essays by Robert Proctor and Olaf Breidbach

PRESTEL

Munich · Berlin · London · New York

René Binet and the
Esquisses

Décoratives **Robert Proctor**

René Binet's *Esquisses décoratives*, like his other work, shows the indulgence and pursuit of an obsession. His interests were diverse, but once initiated were followed with the energy fuelled by an insatiable curiosity. For this reason, Binet is difficult to locate and define. On the one hand, he trained and worked as an architect; on the other, he was a successful painter. He studied nature with his own microscope and the help of academic friends at the Sorbonne, and travelled to Spain and Israel to research Islamic art. His *Esquisses décoratives*, published in four instalments in 1902 and 1903, ranges in scale from suggestions of buildings to pieces of jewellery and motifs for embroidery. Like Binet himself, the book does not easily fit into a single genre or discourse.

The focus in this introduction is on Binet's study of nature and, above all, on his interest in Ernst Haeckel. For Binet, such studies were primarily a means to an artistic end, but at the same time he considered artists to require a knowledge of nature's laws and systems as revealed by science as fundamental to a reasoned and lasting art. Binet's book is significant because it reveals some of the ways in which Haeckel's work could be appropriated by artists. Also in focus here is Binet's involvement with the decorative arts, as the primary subject of the *Esquisses décoratives*. It is important to view the book in relation to earlier discourse on the subject, and this includes a continuous debate on the role of nature in ornamental art, in which Binet appears to promote a specific stance. We can also examine Binet's architecture for clues to the attitudes expressed in the book: the *Porte Monumentale,* produced for the Paris Exposition Universelle of 1900 (fig. 1), was the only major built work he was involved with before the publication of the *Esquisses*; but we can also follow his thinking into his design for the Printemps department store

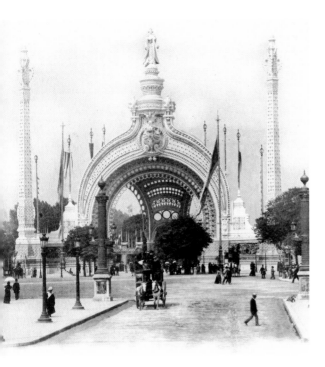

1 | René Binet's *Porte Monumentale* for the Paris Exposition Universelle, 1900

2 | Sponges, from Ernst Haeckel's *Kunstformen der Natur*, 1904 (plate 5); the motif in the bottom left hand corner reappears in Binet's plate *Heurtoir*

3 | Melethallia algae, from Haeckel's *Kunstformen* (plate 34); the cellular patterns are similar to Binet's in *Incrustation de plomb*

extensions of 1907—11. Binet's life was short (1866—1911) and his opportunities to build were, therefore, few, so that the *Esquisses* must be considered a major work in itself, a virtual architecture by a young and dedicated designer at a period of artistic fervour and renewal around 1900.

It is worth noting here that Binet's *Esquisses décoratives* has never been well known or easily available. When first published, the plates were expensive to print and poorly distributed. In one of his letters to Haeckel, Binet requested his help in finding a German publisher, who "would know better than a French publisher how to distribute it in France."[1] He wanted this help for his new proposal for a more affordable version of the *Esquisses*, a version which would also help explain it better, as he complains in the letter, his work and its debt to Haeckel had not been well understood. Binet never wrote an explanation of his work, even in his letters to Haeckel, but relied on his art-critic friend, Gustave Geffroy, to relay his ideas in an introduction. His other writings are very few and fairly conventional. There can really, therefore, be no question of directly understanding his intentions: instead, we can only be concerned with recreating intention in our own time by positioning the *Esquisses* alongside a field of other works, and analysing its contents in the light of other writing and artistic production.

Only a handful of copies of the *Esquisses décoratives* now exist in libraries in Paris and elsewhere, though occasionally plates can be found dangling from string in front of bookstalls along the Seine. The copy used for this edition comes from the Ernst Haeckel Archive in Jena. It is the copy sent to Haeckel by Binet, and dedicated to him in 1902: "To Monsieur Professor Ernst Haeckel, as a token of my gratitude and of my profound admiration."

Studies from Nature

For a definite knowledge of Binet's admiration for Haeckel, we have the letters to thank. They only hint, however, at the forms which that admiration took, and leave us to deduce for ourselves the ways in which Haeckel's work may explain that of Binet. The most evident debt to Haeckel is through his illustrations: it is possible, as others have done, to connect Binet's images directly to their inspiration in Haeckel's plates in the *Kunstformen der Natur* (Art Forms in Nature) of 1899 to 1904.[2]

As Barry Bergdoll noted, the two works formed an exchange, sections were sent back and forth during the process of their creation, mutually informing each other of their development.[3] Take plate 5 of the *Kunstformen*, for example (fig. 2), and compare Haeckel's close-up details of sponges with the lower left-hand door

knocker in Binet's plate *Heurtoir*, where a similar type of pattern occurs. Or compare the Melethallia algae in Haeckel's plate 34 (fig. 3) with Binet's cell-like patterns in *Incrustations de Plomb*. One of Binet's electric lanterns (*Lanterne éléctrique*) is clearly based on the central radiolarium in Haeckel's plate 71 (Stephoidea; fig. 4). Suggesting an influence in the reverse direction is more difficult (especially since only one uninformative letter from Haeckel to Binet survives, a copy of which is at the Musée de Sens). It is particularly interesting that Haeckel should have chosen to illustrate bryozoans in plate 33 of the *Kunstformen*. Binet mentioned these microscopic organisms (relatives of corals) in a letter to Haeckel of 1899, before the *Kunstformen* had appeared, saying he had studied them in the 'Challenger Reports'.[4] However, bryozoans were only a minor part of the 'Challenger Reports', where they were called 'polyzoa'. Binet's source is more likely to have been the earlier nineteenth-century French palaeontologist Alcide d'Orbigny, whose *Paléontologie française* contained a complete illustrated volume on the bryozoans (figs. 5 and 6).[5] These creatures appear in various forms in Binet's *Esquisses décoratives*, turned into wallpaper patterns in 'Papier peint', and reworked in metal in 'Plaque de porte', for example. Perhaps Binet alerted Haeckel to their artistic interest, prompting Haeckel to select from other naturalists' works similar species to those that Binet had used. Whether Haeckel's later choices from nature were informed by Binet's approach can probably never be known. Breidbach argues that Haeckel's vision of nature (both in his selection from it, and his diagrammatic illustration methods) was more broadly informed by Art Nouveau aesthetics, to a knowledge of which Binet would undoubtedly have contributed.[6] What is certainly clear is Binet's dependence on Haeckel throughout for visual inspiration: motifs are taken from the *Kunstformen* and applied in a direct and literal way, with only the minimum of abstraction.

It is also clear that Binet's study of nature extended beyond Haeckel: not only did he evidently read d'Orbigny, but, as his sister's unpublished biography of the architect tells us, he made regular trips to the Natural History Museum in Paris — no doubt mainly to look at the animals, of which many different kinds, from vultures to leopards, and polar bears to monkeys, are scattered throughout the *Esquisses*.[7] Even within Haeckel's work, Binet's visual research went further than the *Kunstformen*. His 1900 *Porte Monumentale* (fig. 7) could not have been based on Haeckel's most well-known work, because the design was prepared before the book. In his first letter, Binet explains that he has been reading the 'Challenger Reports', "with the greatest care for artistic ends, architectural or ornamental: everything, from the general composition to the smallest details is inspired by your studies."[8] He offered to send Haeckel sketches of details of the gate, "and the forms from nature which inspired

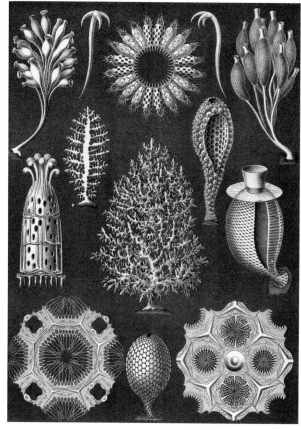

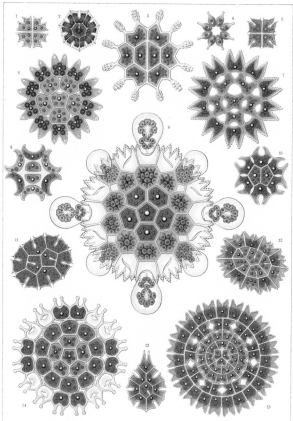

4 | Stephoidae radiolaria, from Haeckel's *Kunstformen* (plate 71); compare with Binet's *Lanterne éléctrique*

them", in other words his own drawings from Haeckel's plates.

The 'Challenger Reports' were a series of fifty volumes published between 1880 and 1895, by a group of scientists who travelled around the world from 1873 to 1876 on the British ship, H.M.S. Challenger, a warship converted into a laboratory. Haeckel's contribution included a three-part volume on the radiolaria (microscopic unicellular organisms with elaborate gemoetrical silicate exoskeletons), with which he expanded his earlier monograph of 1862; his new report of 1887 updated the monograph with the thousands of new species discovered during the voyage.[9] From this work came Binet's first visual adoption of Haeckel's images. The overall form of the *Porte Monumentale* was based on the skeleton of the nassellarium, like that illustrated in plate 65 of the 'Report on the Radiolaria' (fig. 8), and details, including the endless variety of surface patterns, derive from others, such as the porodiscida in plate 46 (fig. 9). The result is a building which, though obviously having its roots in architectural conventions, is given an original style through the very direct use of natural forms. Just as Haeckel's originality lay most importantly in his artistic popularisation of previously unknown natural forms, so Binet's lies in the adoption of motifs from a body of scientific work that had previously not been seriously used for such ornamental and architectural purposes. The *Esquisses décoratives* does this more explicitly than the *Porte Monumentale*, since Geffroy's introduction explains Binet's sources in Haeckel, and with greater polemical intent, since it presents itself as a source book for decorative art and architecture.

An Evolutionary Method

So far we have interpreted Binet's use of nature in a very straightforward way, assuming that his work is simply a matter of motifs transferred from a scientific discipline directly into an artistic one. Binet's own statements tend to reinforce this view of his method. In another letter to Haeckel, Binet thanked the scientist for sending him his earlier richly illustrated monograph on the radiolaria (which we therefore know that he had not discovered before), which he describes as "for me a new source of studies", and in Haeckel's book on corals, *Arabische Korallen* of 1876, he says "I also find wonderful elements of decoration."[10] We also know, however, that Binet was not only interested in Haeckel's illustrations, but in his writing, too. For example, in response to Haeckel's offer to send him books, Binet lists the works he has read, and these include *The Riddle of the Universe* of 1899 and *The History of Creation* (printed in various editions from 1868) both of which were popular derivatives from Haeckel's scientific research, intended to persuade the general public of the truth of

5 | Typical bryozoans from Alcide d'Orbigny's *Paléontologie Française*, 1840–1894 (plate 674)

6 | An unusual bryozoan species, Multilea magnifica, from d'Orbigny's *Paléontologie Française* (plate 740)

evolution.[11] *The Riddle of the Universe* was an application of evolution
to some current problems in philosophy and religious thought, and
it is perhaps because of this work that Binet described Haeckel as
a "great philosopher" as well as a naturalist.[12] Moreover, there is a
textual similarity between one letter and a passage in Haeckel's
Riddle of the Universe which proves beyond doubt that Binet was fully
aware of the scientist's intellectual framework.[13] Haeckel's concerns
were to elucidate a theory of evolution and to elaborate from it an
understanding of man's place in nature. How could such concerns
inform the composition of an artistic work such as Binet's *Esquisses
décoratives*?

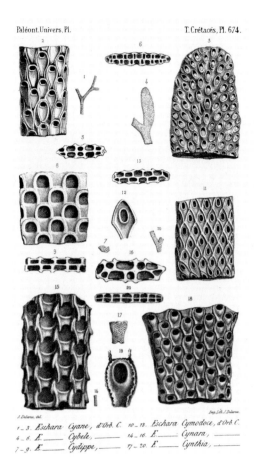

The answer lies in Haeckel's conception of the causes of evolu-
tion in nature's fundamental processes. As Krausse has shown,[14]
Haeckel (unlike Darwin, but much like the early French evolutionist
Lamarck) believed that nature operated according to an internal
force which pushed it towards the development of ever more compli-
cated higher forms of life: in Haeckel's words, "The general doctrine
of development, the progenesis-theory or evolution-hypothesis
(in the widest sense), as a comprehensive philosophical view of the
universe, assumes that a vast, uniform, uninterrupted and eternal
process of development obtains throughout all nature."[15] Such an
idea about the methods of nature in producing its forms has obvious
implications for the artist's conception of his or her own task of
creating form, given a long tradition (originating in the Renaissance)
of a conception of art as imitating the processes, and not merely the
forms, of nature.[16]

This intention is established in Geffroy's introduction to the
Esquisses décoratives, where he explains that Binet has looked to
nature as the origin of all styles, "to the invariable principles, at
once absolute and infinitely varied and complex, which determine
the essential forms and their multiple derivatives." Nature is "for-
ever in movement, forever in production, without a moment's pause
or hesitation", giving artists "the infallible secret of creations and
transformations."[17] Such transformations were thought by Haeckel,
and thus by Binet, to become more visible at the microscopic scale,
with the impression of greater proximity to the workings of nature.
For Haeckel, the radiolaria were a particularly important source of a
knowledge of evolution, because of the many thousands of different
species which could be examined and classified into a linear se-
quence, and yet their underlying physiological similarity, and the
very slight differences between species, which allowed one to trace
the development of forms more closely than was possible with higher
animals (fig. 10). Indeed, as Haeckel explained in his 'Challenger
Report', the more kinds of radiolaria were discovered, the smaller the
distinctions between species became, so that ultimately there were
no separate species at all, but only a continuous spectrum of forms,

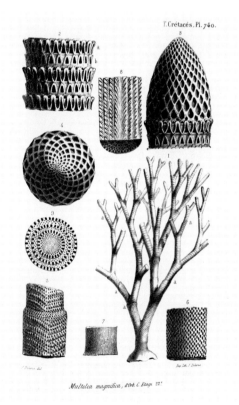

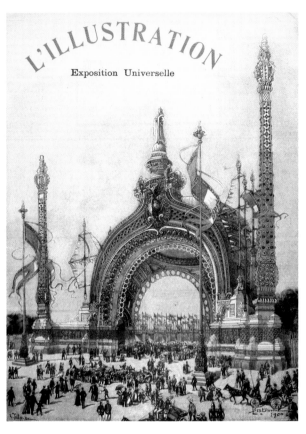

7 | René Binet, *Porte Monumentale*, Paris 1900,
on the cover of a special edition of the newspaper
L'Illustration, 14 April 1900

ranging from the simple actissa (a cell without a shell) to the complex higher forms such as the nassellaria. The radiolaria were therefore a case study showing evolution in operation: "There may be observed in the manifold skeletal forms of the Radiolaria, on the one hand, the utmost accuracy of configuration, and on the other, the greatest variability, and hence a careful comparative study of them leads to a firm conviction of the gradual 'Transformation of Species', and of the truth of the 'Theory of Descent'."[18]

For Binet, the radiolaria and other similar microscopic creatures allowed the artist to observe the methods by which form was developed in nature. Geffroy explained in his preface to the *Esquisses décoratives* that this was the reason for Binet's interest in the microscopic creatures of the sea, from whence life originally emerged, and where it was continually in creation: "There, at the point where science brings us into the presence of one of the phases in the evolution of species, where she surprises it in discovering the unity of matter she always suspected, there has this artist, a most humble and modest student, applied himself to gathering the lessons of forms and movements offered up by the world of things in emergence and growth. From this point he has taken all these lines, all these angles, all these circles, these ellipses, these stars, all these figures which become, at the sweep of his pencil, an extraordinary living geometry."[19] Oddly, perhaps, Geffroy seems to defend Binet's literal and barely conventionalised use of natural forms as, in their superficial appearance, embodying the operation of evolution. This, however, is in accordance with Haeckel's own scientific method of morphology, because it is in the description and analysis of physical forms (categorised according to symmetrical complexity) that the place of an organism in the scale of evolution can be decided. As Breidbach and Richards have shown,[20] Haeckel's science is centred in aesthetics — and so, by extension, Binet's art could therefore be claimed as scientific.

For Binet, as for other Art Nouveau decorative artists and architects, nature was the source for a renewal of art, and a way to avoid the copying of historical styles. Binet's *Esquisses décoratives* show, consistently, a new style; but more importantly, the book also appears intended to offer artists a means for generating original forms. In any of those many plates where a number of variants on a basic form are presented together — the plates *Rosaces* (rose work), *Bouton éléctrique*, or *Clou* (boss) are good examples — there is a lesson that, just as nature has performed an evolutionary variation on the basic form of a radiolarium, so the artist can produce a potentially endless series of forms for these similar decorative objects. In some cases, *Rosaces* again, or *Anneau* (ring), the use of different axes of symmetry to generate these forms is very clear, with degrees of repetition or non-repetition giving gradations of complexity, from lower to higher

forms. Binet's evolutionary method is never quite explicit, and its communication is even hindered by his insistent adoption of realistic natural forms, but the very presence of such varieties of form for similar objects on a single plate seems, through a reading of Haeckel, to be intended as the result of an unseen gradual process of artistic creation analogous to that of evolution in nature.

A Monist Art

This compositional method for artists, a form-making that imitates the methods of nature, is expressed by Gustave Geffroy in his introduction to the *Esquisses*, but was never explained by Binet. On the other hand, Binet does give clues to another purpose behind his work, connected to Haeckel's broader philosophy of monism. In one of his letters, Binet tells Haeckel that "I keep your admirable motto on 'Monism' as the supreme moral expression for the times to come,"[21] revealing his interest in Haeckel's popular writings on the subject, most importantly *The Riddle of the Universe*. Moreover, Binet's sister completes her biography of the architect with a phrase that, she says, he considered essential to his work: "the True, the Good, the Beautiful."[22] This phrase is the motto that Binet refers to, and is taken from Haeckel's writings on monism: "Monistic investigation of nature as knowledge of the true, monistic ethic as training for the good, monistic aesthetic as pursuit of the beautiful — these are the three great departments of our monism: by the harmonious and consistent cultivation of these we effect at last the truly beatific union of religion and science, so painfully longed after by so many today. [...] To this 'triune' Divine Ideal shall the coming twentieth century build its altars."[23] Looking at this aspect of Haeckel's thought gives another dimension to the relationship between the scientist and the architect.

Haeckel, as a "man of science", did not believe that there was a spiritual world separate from the physical universe, but thought that every manifestation of life, including consciousness and will, could be explained entirely by physical and chemical processes: "the 'soul' is nothing more than the sum or aggregate of a multitude of special cell-activities."[24] Yet he attributed to the physical world a fundamental spiritual quality (soul, or psyche), found even in the attraction and repulsion of atoms, and in the general tendency of nature to evolve and develop. Monism, implying the unity of nature (and the identity of the physical with the spiritual), was his name for this attitude, in opposition to the 'dualism' of Descartes and Christians, for whom matter and spirit formed two separate realms. Haeckel hoped that monism would replace Christianity with a religion which had a purely scientific basis. Rather than looking to an afterlife for

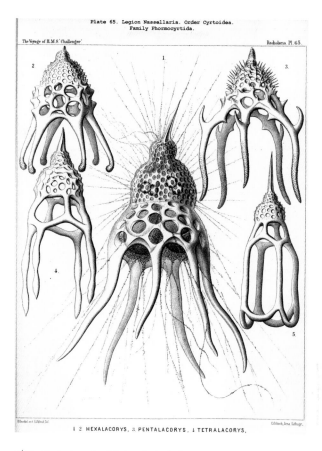

8 | Nassellarium type of radiolarium, the inspiration for Binet's gate, from Ernst Haeckel's *Report on the Radiolaria* (Challenger Report), 1887 (plate 65)

11

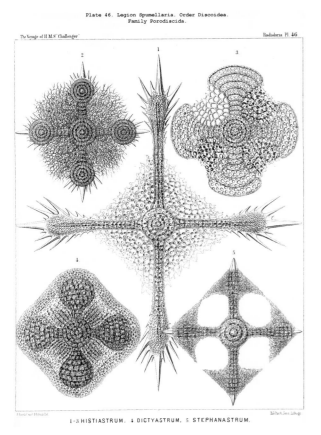

Plate 46. Legion Spumellaria. Order Discoidea.
Family Porodiscida.

The Voyage of H.M.S. 'Challenger' Radiolaria Pl. 46

1-3 HISTIASTRUM. 4 DICTYASTRUM. 5 STEPHANASTRUM.

9 | Porodiscida type of radiolarium, from Haeckel's
Report on the Radiolaria (plate 46)

their happiness, the adherents of this religion would find their consolation in the world around them, in nature, and in a knowledge of their fleeting existence in a continuously developing natural system.[25]

His three categories encompassed different, related, areas of human activity. The True, the first of these categories, was the concern of scientists, who, with telescopes and microscopes, revealed the workings of the universe. The Good was the preserve of philosophers and politicians, who would work out a system of human ethics without the need for divine justification. The Beautiful, meanwhile, belonged to art, about which Haeckel had several things to say. The role of the artist was twofold: firstly, to bring the "inexhaustible treasures of beauty" in nature to the attention of ordinary people, who would therefore find delight in their artistic surroundings, and through them would learn to love the natural world as well; and secondly, to educate people about the scientific understanding of the world, the connections between natural phenomena, the underlying unity of everything in nature, and the "wonderful truths of the evolution of the cosmos".[26] Binet, it seems, considered himself as Haeckel's monist artist, in both respects.

In the first case, his *Esquisses décoratives* makes beauty out of the raw material of nature. Haeckel's *Kunstformen der Natur* took the opposite direction, presenting nature in such a way that it exemplified current standards of beauty. Binet, taking Haeckel's work for a literal depiction of nature, reinscribed it literally into his art. This is emphasised by Binet's juxtaposition of lower and higher forms of life. If a vulture or a leopard is presented alongside a figure from a radiolarium (as in *Heurtoir*, for instance), one is forced to confront the two types of creature in the same representational mode. Without the bird or mammal, one might mistake the use of a microscopic organism for an abstract motif. With the two placed together, we become aware that what seem like endlessly inventive patterns are actually taken from nature with a minimum of mediation. Binet's images therefore didactically convey their inspiration in natural forms. Moreover, Gustave Geffroy's preface explained that Binet went directly to nature to avoid imposing a personal style on his work, which would have degraded the original forms in nature.

In the second case, Binet's *Esquisses* appears to show some concern with Haeckel's desire for an art that teaches its viewers about the relationships between things in nature. When he wrote this, Haeckel appeared to have landscape painting in mind, which, without any great shift in its conventions, could take an ecological turn.[27] His *Kunstformen*, in giving forms intended to be applied to a wider range of artistic disciplines, displays a more widely applicable method of revealing the unity of nature. Since its plates jump from higher to lower species types and back again in no particular order,

the viewer searches instead for a deeper aesthetic order: similar motifs emerge at different scales in different places. Any number of comparisons can be made within the work, which perhaps owes its perennial fascination to this quality. The patterned scales of the boxfish (plate 42, Ostraciontes; fig. 11) take on the same forms as the microscopic patterns of algae (plate 34, Melethallia, fig. 3), which recall the horizontal cross sections of jellyfish (plate 18, Discomedusae; fig. 12), and so on. Haeckel's images, carefully selected from nature and reworked to allow such connections, thus argue eloquently for his idea of a nature with a unified and universal force of development.

Binet's book uses a similar technique for, it seems, the same purpose. Similar natural forms are used across the work at different scales. The echinid (sea urchin) motif, for example, is common: consisting of an elongated hemisphere decorated with vertical ridges of dots, it appears in places as diverse as a balcony (*Balcon*), the top of a tower (*Couronnement de Tours*), or the head of a pin (*Bijou*). Other forms, including the nassellarium and the bryozoan, can similarly be detected in different places throughout the work. In the same way as Haeckel, Binet isolates parts of objects and magnifies them, so that, like the organisms in the *Kunstformen*, smaller details of objects are shown to contain the same patterns and motifs that occur at other scales. The impression given by the *Esquisses* is of nature perceived as a coherent system, and of Binet's own decorative objects as a part of that natural system. Human beings, surrounded in their daily lives by this environment, become embedded within it, and are prompted to consider their place in the natural world.

For Binet, Haeckel gave access to the forms of nature, and especially to the new forms revealed by modern science. Both Haeckel's written works and his *Kunstformen der Natur* also informed Binet of the scientist's ideas about nature, specific to his version of evolution, and with implications for the forms of Binet's art. And finally, Binet could also look to Haeckel for a conception of the role of the artist, as propagandist for a scientific religion which sanctioned the aesthetic enjoyment and understanding of nature. If Binet's sources for a knowledge of nature were more diverse than the connection with Haeckel alone reveals, nevertheless it is to the German naturalist that he owed his wider conception of how nature operated, and the ways in which his art could put this conception into practice.[28]

10 | Typical sequence of radiolaria, from Haeckel's *Report on the Radiolaria* (plate 44)

11 I The boxfish, from Haeckel's *Kunstformen* (plate 42)

Materials in the Decorative Arts

While the connection between Binet and Haeckel is one of the most interesting ways of looking at the *Esquisses décoratives*, because it is where Binet's greatest originality lies, it is important also to see the book in its wider context of other such publications in the decorative arts throughout the nineteenth century. In doing so we reconstitute another view of Binet himself: the artist obsessed with nature as seen through Haeckel's images now becomes the designer working out systems of decoration for different crafts, to be employed as inspiration by other designers and craftsmen in their work. Binet's use of nature takes on another significance within a larger discourse about the artistic adoption of natural forms in the decorative arts.

It is clear from the organisation of the book that it is intended to appeal to designers as well as architects, because the practitioner of any one craft can easily recognise the place of his or her field of work in the overall scheme. Binet's book is an alphabetical encyclopaedia of techniques and objects, not abstract stylistic motifs; in other words it is an application of nature to craft, through an engagement with the real methods and productions of existing craftsmen. The jeweller will look at *Anneau* and *Bijou*; the metal worker will look at *Balcon*, *Fer forgé* (wrought iron) and *Lanterne éléctrique* (indeed the metal worker is very well catered for by Binet's book); the ceramicist will dwell on *Céramique* and *Faitage, crête* (roof ridge); and so on. Like other encyclopaedias, it attempts to cover the complete extent of its subject, although since it is organised alphabetically, it does not do so in any logical order.

The result of Binet's categorisation by decorative technique or object is that his ideas are bound by conventional forms, from the limitations of which arises the book's ultimate failure to innovate. This is more apparent in some plates more than others. It is tempting, to prove Binet's originality, to extract from his work for discussion those plates (*Brique ornée*, *Incrustations de plomb*, etc.) that show an apparently radical new use of natural forms. One could equally well select a series of plates to prove the opposite case, that Binet was so heavily constrained by convention that he was unable to propose a fundamentally new way of working in the decorative arts. For example, the plate *Clef* shows keys with elaborate handles, but there is nothing new or unusual about the objects: they are otherwise traditional keys, with only the application of a different type of ornament to a part of them to distinguish them from any others produced over hundreds of years. The same goes for many other plates. *Abri* (shelter) has some link to traditional Chinese wooden structures, and appears to use the same nassellarium form that Binet used in the *Porte Monumentale*, but these are only minor manipulations of a standard form. Plates such as *Chapiteau* (capital),

Magasin (shopfront), or *Pochoir* (stencil) seem even to lack Binet's usual effusive inspiration, so familiar do they appear in their overall forms. This seems largely the result of Binet's titles, and the conception of the work, which, in breaking down the vast field of decorative art into specific, narrow areas, precludes a fundamental rethinking of the role of decoration. Only occasionally, when an architectural ensemble is represented (*Porte*, showing an entrance and interior as well as details for a *Maison du peuple*, for example), do we approach a conception of the decorative arts as collaborators in a total artistic environment, in the manner of Binet's contemporaries such as Victor Horta or Charles Rennie Mackintosh. It is almost as if every metal-worker or jeweller needs only to make a change in style for this new and all-enveloping art of nature to appear; but for that very reason, it does not represent any kind of challenge to an established order. The dependence of architecture and design on applied ornament (the pressing need for a capital at the top of a column, or a pattern to fill the space at the end of a bench) is continually emphasised.

Such a challenge was not Binet's purpose. Instead, he engaged with the existing practices of craftsmen to inflect them towards a novel style based on Haeckel's evolutionary and microscopic nature. In each plate, he studied a technique, attempting to work out how that technique could best accommodate his favourite forms. From an understanding of the methods of working a material comes the choice from nature. So, for example, the *Lanterne éléctrique* takes the shape of a radiolarium because this creature offers a model for a protective latticework around a delicate central element, while his *Brique ornée* is based on the repeating patterns of bryozoans because they can easily be created using moulded bricks. Bryozoans and corals appear in *Banc* (bench), where their forms seem appropriate for the carved decoration in wood and for the specific outline shapes into which they are inserted, but seem to be chosen from different species to those used for the brickwork (and different views of those species) so that they are appropriate to the decorative situation. While there may be a minimum of conventionalisation of nature, there still remains the necessity for intelligent selection.

Rather than impose forms on the material to which it cannot easily adapt itself, Binet has therefore chosen forms which can easily be worked. This shows his inheritance of nineteenth-century ideas about the decorative arts. In most writing on the subject the importance of designing in accordance with the material is clear: the nature of the material and the ways in which it is cut, carved, mould-ed, or forged are to be emphasised in the forms it takes. In his 1885 book *La Composition décorative*, the architect Henri Mayeux impressed on the budding designers for whom he wrote the need to expose manufacturing techniques in a design. In wooden furniture, for example: "the structure must be accentuated as far as possible,

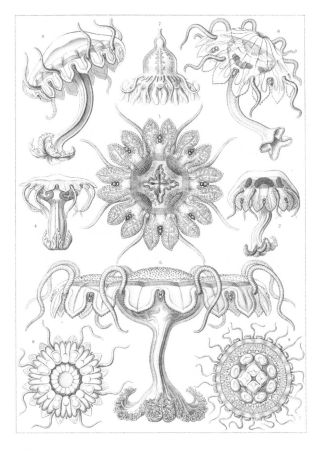

12 | Discomedusae jellyfish, from Haeckel's *Kunstformen* (plate 18)

Carrelage. Ancolie Fig.166

13 a

Pavement Nenuphar Fig. 169.

13 b

in other words the givens of the vertical and horizontal elements and the panels;" wrought iron should be designed appropriately with cut-out shapes and raised forms created by hammering; embroidered and printed cloths should have two-dimensional patterns to emphasise the use of blocks and lines of colour in making them. Jewellery seemed to require a degree of 'fantasy' in decoration, because the materials were easy to work, and did not have to withstand rough treatment in use.[29]

In making such statements, Mayeux himself relied on an earlier discourse in the decorative arts (mostly written by architects), perhaps deriving from Owen Jones's *The Grammar of Ornament* of 1856 ("Construction should be decorated. Decoration should never be purposely constructed. That which is beautiful is true; that which is true must be beautiful"),[30] itself derived from A.W.N. Pugin's *True Principles of Pointed or Christian Architecture* of 1841. In France, this idea that design could have integrity through the honest accentuation of materials and techniques was firmly established by the architect Viollet-le-Duc, in, for example, his *Entretiens sur l'architecture* of 1858—72. It was subsequently pursued in writing on architecture in the late nineteenth century by architects such as Paul Sédille and Lucien Magne (who described the concept as "Rationalism"),[31] and into the early twentieth century by, amongst others, Frantz Jourdain. Jourdain, as Meredith Clausen has shown, was particularly important in promoting this 'Rationalist' approach to materials as an aspect of Art Nouveau.[32]

Other Art Nouveau decorative arts books incorporated this tendency into their approach. The classic French examples are M. P. Verneuil's two books, *Étude de la plante* and *L'Animal dans la décoration*, both published around 1900. Verneuil proposed two rules: "the study in depth of the principle supplied by the motif, and that of the technique of the craft which must produce it."[33] Discussing materials, he asks: "Why wish to dissimulate the process, while it is just that which must give the work its character? The worker must be able fully and freely to give reign to his professional abilities, and must value, as much as possible, the material employed."[34] Like Binet, he organised his *Étude de la Plante* by decorative techniques (figs. 13 and 14), showing how real plant species could be used as inspiration in different materials.

While Binet's decorative art is, by today's standards, opulent and indulgent, and by the standards of most of the twentieth century would have been considered decadent, it nevertheless complies with the nature of materials and the arts of working them in a logical and reasoned way. It does this not only through an appropriate selection of natural forms, but also through its use of conventions. The decorative hinges in *Plaque de porte* and *Penture* are flat because they are cut out of sheet metal, like medieval door hinges; the tiles in

Carrelage use two-dimensional patterns of colour, and use their repetition to create geometrical patterns, like tiles from the Netherlands or the Islamic middle east; *Fer forgé* shows a range of patterns that are amenable to craftsmen in wrought iron, and are reminiscent of rococo balustrades and railings in France. History and tradition, carefully considered and edited, provide the models for a rational approach to craftsmanship.

Nature and Style

Throughout the nineteenth century, another theme was particularly important in writing on the decorative arts: that of the conventionalisation, or stylisation, of nature. Ornament and decoration were, throughout history, based on natural forms, but the question that preoccupied nineteenth-century writers was the degree to which those forms were distorted or abstracted, either for cultural and symbolic reasons, or in order to be used more easily in a given material. As we have seen, Binet's use of nature in the *Esquisses décoratives* was as direct as it could be, and deliberately highlighted as such, and Geffroy's preface argued for a literal adoption of nature. Only when the technique dictated an abstracted approach did Binet depart from this: in *Pochoir*, or *Papier peint*, for example, where animals are turned into diagrams that are suitable for printing.

Nineteenth century writers can be characterised by their polemical stances on this subject. Some, like Owen Jones, argued that greater stylisation showed a higher level of culture, since it exhibited a greater degree of mental activity: "in the best periods of art, all ornament was rather based upon an observation of the principles which regulate the arrangement of form in nature, than on an attempt to imitate the absolute forms of those works; and that whenever this limit was exceeded in any art, it was one of the strongest symptoms of decline: true art consisting in idealizing, and not copying, the forms of nature."[35] The "principles" consisted of symmetry, regularity, and forms of growth, explored by, amongst others, Christopher Dresser, who was awarded a doctorate by the University of Jena for his application of botanical studies to ornamental art, and contributed drawings of plants to Owen Jones's book.[36] While such attention to the principles of natural forms may underlie Binet's work, for a justification of his continuing use of realistic forms from nature one can look to arguments from the opposing side.

Mayeux divided all ornamental forms into three modes: those imitating nature directly; the purely conventional (geometrical or symbolic); and the mixed (stylised nature).[37] Unlike Owen Jones, Mayeux gave no hierarchy to his system, seeing all modes as valid depending on the context. Auguste Racinet, in his book *L'Ornement*

14 | Ironwork based on mistletoe, from Verneuil's *Étude de la plante* (p. 291)

13 a + b | Floor tile patterns based on specific plant species, from M. P. Verneuil's *Étude de la plante*, c. 1900 (p. 128)

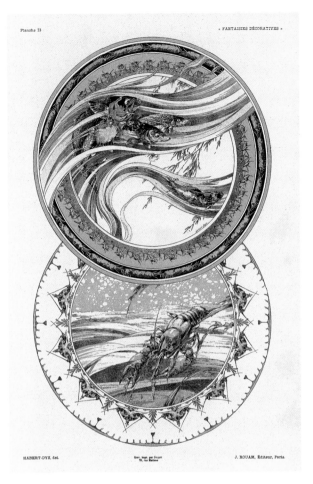

15 | Plate designs from J. A. Habert-Dys' *Fantaisies décoratives*, 1886–1887 (plate 13)

polychrome of 1869—87, attempted to rival Jones's book, but, also unlike him, did not dismiss naturalistic ornament, seeing it instead as a justifiable modern tendency: "it is when approaching modern times that we most frequently meet with this individualizing style, the especial aim of which is to give the most exact rendering of the object represented, to express it with all its accidental modifications, reliefs, and shades of colour. [...] This style, the results of which are less severe and more delicate than those of the two others, arose from the increased use of painting in the domestic arts, and the improvement in the manual skill of the artist, and was thus well suited to the refined and elegant tastes of an advanced civilization."[38] Thus the degree of complexity and skill in carrying out decorative work, rather than the mental operation involved in designing it, is his measure of culture. In writing this Racinet had in mind the France of the seventeenth and eighteenth centuries, whose decorative arts were also a source of inspiration to French Art Nouveau designers.

Thus in France the debate over naturalism and stylisation was not as weighted towards the latter as it sometimes was in Britain. A book of decorative ideas like Habert–Dys's *Fantaisies décoratives* of 1886—87 seems extraordinary to us today: on plates, fans, jewellery, and so on, are realistic and occasionally rather disturbing images of animals, including swallows, cats, house flies and lobsters — the latter represented as a picture in the middle of a plate and surrounded with a border composed of repeated anatomical images of its head (figs. 15 and 16).[39] Binet, like late-nineteenth-century and other Art Nouveau decorative artists in France, could justifiably propose an ornamental art based on an apparently unmediated use of natural forms.

The word 'apparently' is important here: while Binet and Geffroy considered the use of nature to obviate a personal style, in perusing the plates of the *Esquisses décoratives* we nevertheless recognise a consistent appearance, a personal Binet style. However literal the use of nature was intended to be, it could never escape a degree of adaptation to the habits of the artist's hand. If the radiolaria are chosen for their geometrical regularity, the same cannot be said of a polar bear or a monkey, and yet these are given a distinctive spikiness by Binet's drawing method which unites them with these lesser creatures.

More importantly, one could use Binet's *Esquisses décoratives* to question the very categories of nature and convention. The separation of the two in nineteenth century discourse constitutes a position on the relationship of nature to humankind: the works of nature are natural, and the works of man are artificial or conventional, and therefore there must be some unbridgeable gap between the two. As Binet's approach can be related to Haeckel's

evolutionary science, we can assume their position on the place of humanity in nature to be the same: in other words, that men and women are part of nature, having gradually evolved from lower species. When human figures (on top of the *Porte Monumentale*, or in the plate *Voussure et arc*, for example) are integrated with forms from nature, it seems that human beings are represented in the same way as Binet's cats and parrots, as inextricably tied to a natural system. Binet's attempt to embody the processes of nature within his work, as well as its forms, also establishes a concept of the artist, and artistic work, as fundamentally natural, part of nature and therefore sharing its creative principle. All historical examples of decorative art and architecture, the results of human creative activity in the past, are therefore also the creations of natural organisms — rather like the shells of radiolaria. From this consideration perhaps arose Binet's interest in non-Western styles, particularly Islamic architecture and decoration, to be studied and used in the same way as other sources from nature. In Binet's work, nature appears to inform his art so that art itself can claim to be completely natural. Today, however, we must argue that no work of art can really be natural; indeed the choice to be 'naturalistic' is one that carries cultural associations, and, as Breidbach has shown of Haeckel,[40] even the knowledge of what nature is depends entirely on the cultural context from which it is viewed.

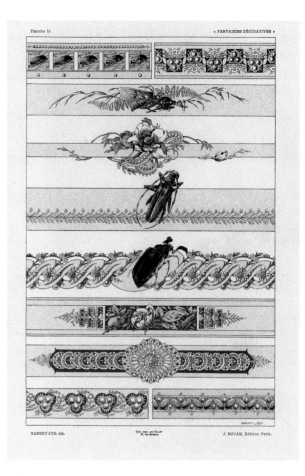

16 | Jewellery designs from Habert-Dys' *Fantaisies décoratives* (plate 15)

The Culture of Ornament

Binet's book also cannot help inheriting a template from earlier ornamental pattern books, a cultural form that acts as a frame for his putatively natural style. Owen Jones's *The Grammar of Ornament* and Racinet's *L'Ornement polychrome* are typical in the way that decorative styles from the past and from both European and non-Western cultures are represented in dense images showing a great variety of forms together, classified by period and place and decorative technique (figs. 17 and 18). As so often in Binet's plates, the different forms are organised symmetrically, either as diagrams or in perspective views. Compare, for example, Binet's plate *Rosace* with Racinet's Arab 'rose work', taken from a Koran manuscript (fig. 19), or the method of layout in Binet's *Rinceau* with Racinet's 'Greco-Roman' friezes (fig. 20).[41] The crucial difference between such books and Binet's work is that the former always show historical examples, while Binet's are his own inventions.

Paradoxically, Jones stated that his intention in bringing together a vast range of historical samples was to encourage decorative artists to avoid copying historical styles, and instead to invent new ones based on the underlying principles of beautiful ornament.[42]

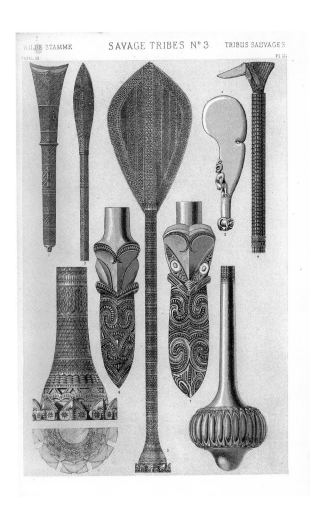

17 | Clubs from 'Savage Tribes', in Owen Jones'
The Grammar of Ornament, 1856 (plate III)

Binet's intention was perhaps similar, and in following the model of such books he also adopted their audiences and addressed their expectations. The eventual limitations of his book are also similar, however: just as Jones doubted that his own book would succeed at first ("It is more than probable that the first result of sending forth to the world this collection will be seriously to increase this danger-ous tendency" of copying),[43] Binet's illustrations are also so fully worked out, as if to be imitated, that any principles at work are eclipsed by the specificity of his forms.

Ornamental pattern books presented their samples in great number, symmetrically on the page, to emphasise the variety that was possible within a single type of decorative work and even within a single culture. Earlier, I suggested that Binet's variety could claim to be the result of an evolutionary method within the artist's creative mind. In these mid-nineteenth century books, the art of societies is the subject, and the process of producing variety is one of gradual changes made by individuals to existing models. There are no explicit references to evolution (Jones was, in any case, writing before Darwin), but to see these works around 1900, through a knowledge of Haeckel, and through further later discourse that used evolution as a historical model for art and design, might have given them a new lease of life as objects of study, and a new interpretation as evidence of patterns of development in human culture.

Binet shifts any such evolutionary model of the history of decorative art to the individual artist. If we follow Haeckel's 'bio-genetic law', his approach makes sense. Haeckel thought that every individual of a species underwent the same process of development in its own growth (particularly during its formation as an embryo) as the whole of its species' evolution, beginning as a single cell, and progressing according to the same law of evolutionary develop-ment that obtained throughout the world. His book *The Evolution of Man* showed how the embryology of human beings revealed their evolutionary descent, to explain this law.[44] Binet therefore provides a model for artistic method which is founded on the natural method of evolution, which applies to the history of human culture as much as it does to the individual development of artistic form, and to both of these in the same degree to which it applies to the rest of nature.

Furthermore, to view these pattern books in the light of Haeckel's plates in the 'Challenger Reports' or the *Kunstformen* produces interesting connections between the works of the naturalist and these earlier purely artistic works. Haeckel's plates are comparable in presentation, laid out symmetrically to show the great variety present in groups of similar species. Haeckel presents his science as well as his art as ornament, in doing so establishing the potential both for an evolutionary reading of ornament in the use of the earlier

books, and for an ornamental reading of nature in his own. Binet crossed the gap between the two fields, connecting them together with his *Esquisses décoratives*, and with it produced a visually intellectual and coherent argument as well as a coherent visual work.

The Architect as Artist

Binet's complaint to Haeckel that his *Esquisses décoratives* was not well distributed or understood, and the limited availability of the book today, confirm what one suspects, that the influence of the work on subsequent Art Nouveau was negligible. If similarities can occasionally be detected in some later works by other decorative artists or architects, one could quite reasonably claim that they would have occurred anyway without Binet's work, given the general excitement around 1900 with natural forms, including those from the sea, and the international accessibility of Haeckel's *Kunstformen*.[45] Binet's book had several limitations: as we have seen, it maintained a fundamentally conservative notion of the categories and forms of decorative art and architecture, and so appeared rather as a personal exercise in style than a work with any polemical intent. If Binet studied the techniques of the different crafts with a view to making convincing designs for the use of craftsmen, this also constituted a conservative and increasingly out-dated approach to design.

The evocative portrait of Binet by his friend Henri Bellery-Desfontaines (fig. 21) shows the architect immersed in the study of shells and radiolaria, their forms absorbed and reworked by his imaginative genius, which projects onto his physical environment their complex shapes ready to be transcribed into architecture or art. This portrait is similar to that of the French Art Nouveau glassmaker Émile Gallé by Victor Prouvé, which shows the craftsman holding a vase onto which his concentration is focused, the swirling paintwork which surrounds him showing that a mental state is captured and distilled into the form of the vase.[46] There is an essential difference between these two artists, however: Gallé was a craftsman, forming his work with his own hands (and so the transition of emotion into his work could be justified as physiological); Binet, however, was an architect, drawing his designs to be manufactured by others.

In this he was a typical 'Beaux-Arts' architect, trained as he was at the École des Beaux-Arts (School of Fine Arts) in Paris to design every detail of his work. In Binet's most significant later work of architecture, the extension to the Printemps department store in Paris, begun in 1907 and partially completed in 1911 (shortly before the architect's death that year; figs. 22 and 23), we see a subdued realisation of the aims of the *Esquisses décoratives*: the blue and green glazed dome over the atrium suggested an underwater world,

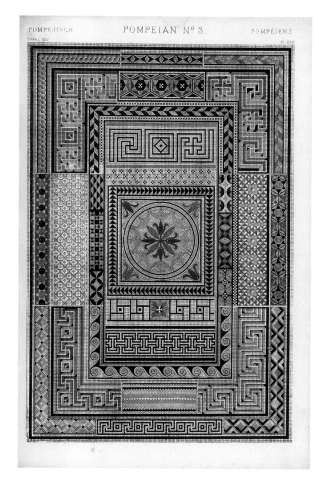

18 | Mosaic floor patterns from Pompei, in Jones' *The Grammar of Ornament* (plate XXV)

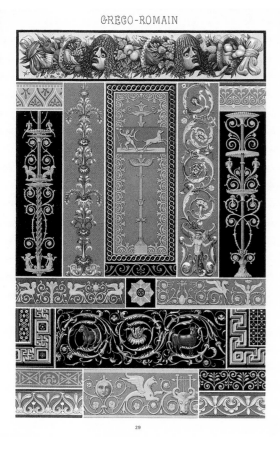

19 | Arab rose work ('rosaces'), from August Racinet's *Polychromatic Ornament*, London 1877 (plate XXVII)

20 | Greco-Roman friezes from Racinet's *Polychromatic ornament* (plate IX)

while the decorative treatment of every element of the interior derived from nature — mostly plants rather than sea-creatures, however.[47] While some work was given to decorative artists, notably the lamps in the porch by René Lalique, Binet's attention to every detail of the building was emphasised at the time, particularly through the use of his sketches, which the architect had carefully conserved and made available for publication (fig. 24).[48] These showed that, rather than allow freedom to individual craftsmen to create their own contributions to the interior, Binet dictated every line of the ironwork balustrades, balconies and capitals.

This all-encompassing work of design, to ensure that all aspects were entirely coordinated in a seamless whole, the result of the supreme mental effort of a single individual, faithfully translated into reality by craftsmen, was opposed by other developments in Art Nouveau in France. The architect Frantz Jourdain undertook a similar project for a department store in Paris, the Samaritaine of 1903—10, but made it his concern as architect to ensure a high degree of freedom for the decorative artists he commissioned: the signage on the exterior, for example, was produced by the graphic artist Eugène Grasset, and is entirely typical of his style. Jourdain promoted team-work over individual genius, the architect acting as the coordinator of a collaborative artistic project.[49]

This difference between Jourdain and Binet, shown in their department store buildings, reveals further difficulties with the *Esquisses décoratives*. It would never have occurred to Jourdain to carry out such a work, since it appears to prescribe so much to craftsmen, thereby precluding their artistic independence. For the same reason, such a work cannot have been attractive to the craftsmen it seems to have been aimed at: while there may be prin-ciples to be observed in Binet's work, it was ultimately stylistically too prescriptive, closing down the possibilities for design. Haeckel's *Kunstformen der Natur*, by contrast, was suggestive, and open to reinterpretation by artists or designers — which explains its success on publication, and its longevity.

An article by Binet on the training of architects at the École des Beaux-Arts asserted that students were not given a sufficient edu-cation in the realities of building construction, and the materials and processes involved in the crafts that contributed to architecture.[50] He proposed that, besides the elaborate drawing exercises that were currently required, students learn by hands-on experience how different materials are worked. This argument reinforces for us Binet's concept of himself, and of the role of the architect in general, as that of the artistic genius: it was precisely through such practical knowledge of the crafts that architects could extend their aesthetic control over craftsmen to dictate a complete design. We can see the *Esquisses décoratives* in the light of this article as Binet's own

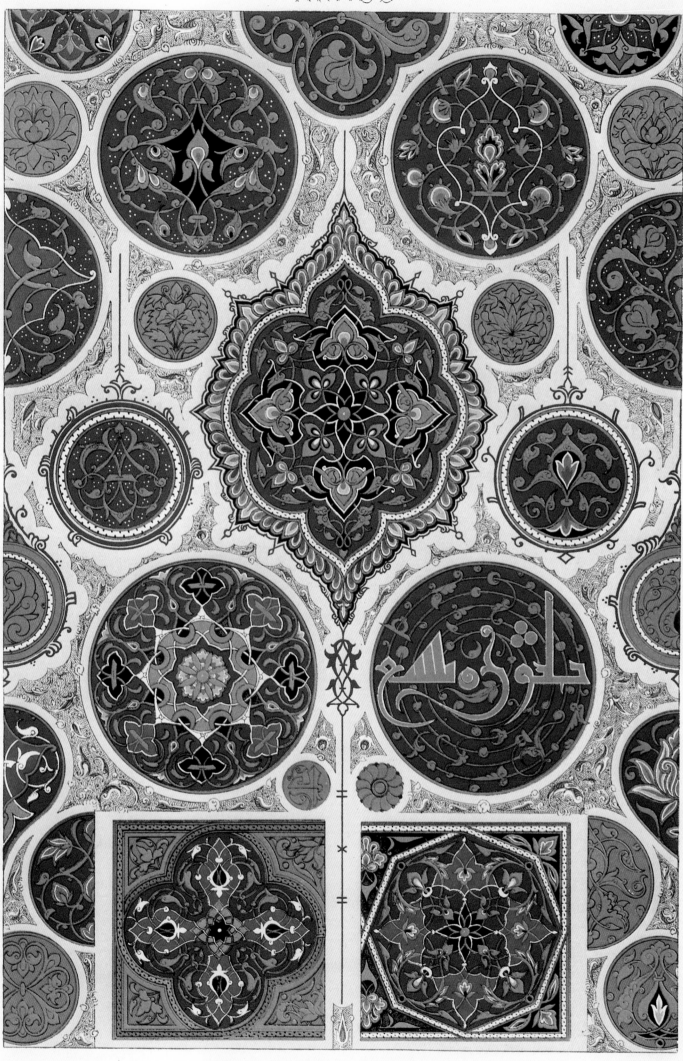

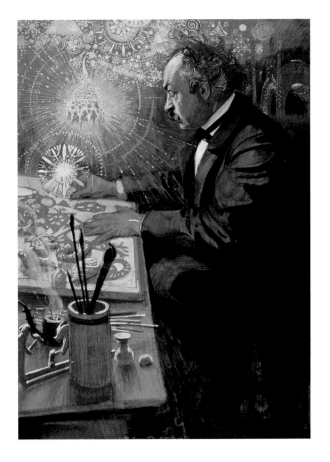

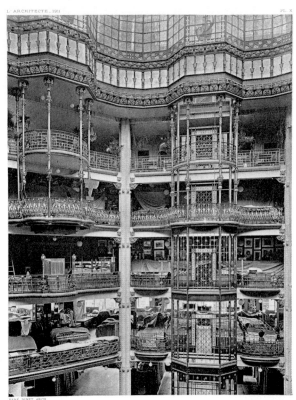

NOUVEAUX MAGASINS DU 'PRINTEMPS'
Boulevard Haussmann, à Paris
Grand Hall

21 | Portrait of René Binet by Henri Bellery-Desfontaines, 1904

22 | Interior of René Binet's Printemps department store extension, 1907–1911

23 | Interior of Binet's Printemps department store extension, 1907–1911. The building burnt down in 1921

24 | Sketch by Binet for staircase railing of Printemps, 1907–1911, published in *L'Architecte*, 1911

attempt to supplement his inadequate education. Learning the different crafts for himself, attending to an encyclopaedia of decorative techniques and architectural details, enabled him to develop and exercise his style, to prepare for the reality of building which he hoped would follow. Thanks to his dedication to this task and the publication of his work, we become witness to his remarkable personal vision when we look at the plates of the *Esquisses décoratives* today.

The Importance of the Esquisses Décoratives

Despite its limitations, the book is nevertheless both a captivating manifestation of Art Nouveau, and an important historical document. It is exceptional in allowing us to view the reception of Haeckel's work, absorbed through meticulous study, in an artistic context, and to see the ways in which Haeckel's writing, as well as his imagery, could inform an artistic conception of nature and its role in art around 1900. The *Esquisses décoratives* prompts more questions than it answers, but whose terms it frames for debate: about the role of nature and its representations in art and design; the interactions between artistic creation, and conceptions of history and nature; about the nature of ornament; and the operations of the designer.

It gives a fascinating glimpse into the mechanics of the relationship between art and science in its period, exposing the mechanism to view for our inspection, and potentially allowing for new conclusions about similar relationships elsewhere in Art Nouveau design and beyond. At the same time, it is a delight to look at, a privilege previously only available to those who discovered it in libraries, and now, as Binet himself had hoped, available to all.

Acknowledgements

Research for this essay was carried out with a grant from the British Academy. Thanks are also due to: Thomas Bach, Sylvie Ballester-Radet, Barry Bergdoll, Olaf Breidbach, Ruth Hanisch, Claire O'Mahony, Diana Periton and Wolfgang Sonne.

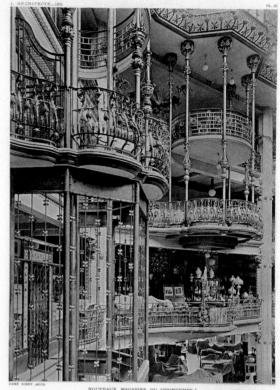

NOUVEAUX MAGASINS DU "PRINTEMPS"
Boulevard Haussmann à Paris.
Grand Hall balcons et cage d'ascenseur

1 René Binet to Ernst Haeckel, 8 November, 1904, Ernst Haeckel Archive, Jena (henceforth EHA).
2 Erike Krausse, 'Haeckel: Promorphologie und "evolutionistische" ästhetische Theorie: Konzept und Wirkung', in Eve-Marie Engels (ed.), *Die Rezeption von Evolutionstheorien im 19. Jahrhundert*, Frankfurt 1995, pp. 347–94; Ernst Haeckel, *Kunstformen der Natur*, Vienna 1904.
3 Barry Bergdoll, 'Les *Esquisses décoratives* de René Binet', in Lydwine Saulnier-Pernuit, et al., *René Binet, 1866–1911: un architecte de la Belle Époque*, Sens 2005, pp. 101–09 (p. 105).
4 Binet to Haeckel, 12 March, 1899, EHA.
5 Alcide d'Orbigny, *Paléontologie française: description des mollusques et rayonnés fossiles*, Paris 1840–94, atlas: vol. 5, text: section 2, vol. 5.
6 Olaf Breidbach, 'Brief Instructions to Viewing Haeckel's Pictures', in Breidbach et al, *Ernst Haeckel: Art Forms in Nature*, Munich 1998, pp. 9–18 (p. 14); see also, Olaf Breidbach, 'Naturkristalle: Zur Architektur der Naturordnungen bei Ernst Haeckel', in S. Klaus et al (ed.), *Architektur weiterdenken: Werner Oeschlin zum 60. Geburtstag*, Zurich 2004, pp. 254–75.
7 Marguerite Bauban-Binet, unpublished biography of René Binet, 1945, Musées de Sens, p. 87.
8 Binet to Haeckel, 12 March, 1899, EHA.
9 Ernst Haeckel, 'Report on the Radiolaria', *Report of the Scientific Results of the Voyage of H.M.S. Challenger*, Zoology, vol. 18, London 1880–95 (1887); for Haeckel's 1862 monograph on the radiolaria, see Olaf Breidbach, *Ernst Haeckel: Art Forms from the Ocean*, Munich 2005.
10 Binet to Haeckel, 17 May, 1902, EHA.
11 Binet to Haeckel, 8 May, 1902, EHA. The books referred to are Ernst Haeckel, *The Riddle of the Universe*, London 1900, and Ernst Haeckel, *The History of Creation, or the Development of the Earth and Its Inhabitants by the Action of Natural Causes*, New York 1892 (4th edition).
12 Binet to Haeckel, 10 July, 1903, EHA.
13 Compare Binet to Haeckel, 4 October, 1904, EHA, to Haeckel, *Riddle*, p. 285.
14 Krausse, p. 359.
15 Ernst Haeckel, *Freedom in Science and Teaching*, London 1879, p. 2.
16 See Jan Białostocki, 'The Renaissance Concept of Nature and Antiquity', in I. Rubin (ed.), *Studies in Western Art: Acts of the Twentieth International Congress of the History of Art*, Princeton 1963, vol. 2, 'The Renaissance and Mannerism', pp. 19–30.
17 Gustave Geffroy, preface, in René Binet, *Esquisses décoratives*, Paris 1903, p. 2.
18 Haeckel, 'Report on the Radiolaria', Introduction, part I, p. civ.
19 Geffroy, p. 13.

20 Breidbach, 'Naturkristalle'; Olaf Breidbach, 'Körperkristalle: Haeckels
 Natursymmetrien', in *Praxis der Naturwissenschaft Physik i.d. Schulen*, 52 (2003),
 pp. 17—22; Robert J. Richards, 'The Aesthetic and Morphological Foundations of Ernst
 Haeckel's Evolutionary Project', in M. Kemperick and P. Dassen (ed.), *The Many Faces
 of Evolution in Europe, 1860—1914*, Amsterdam 2005, pp. 1—16.
21 Binet to Haeckel, 9 November, 1904, EHA.
22 Bauban-Binet, p. 106.
23 Ernst Haeckel, *Monism as Connecting Religion and Science: The Confessions of Faith
 of a Man of Science*, London 1894, pp. 86—87.
24 Ernst Haeckel, *Freedom in Science and Teaching*, London 1879, p. 49.
25 Haeckel, *Riddle*, e.g. p. 336.
26 Haeckel, *Monism*, pp. 83—85.
27 Haeckel, *Riddle*, pp. 343—44.
28 For a more detailed account of Binet's monism, see Robert Proctor, 'Architecture
 from the Cell-Soul: René Binet and Ernst Haeckel', in *Journal of Architecture*, vol. 11,
 no. 4 (September 2006), pp. 407—424.
29 Henri Mayeux, *La Composition décorative*, Paris 1885, pp. 188 (wood), 202 (ironwork),
 280 (cloth), 213—14 (jewellery).
30 Owen Jones, *The Grammar of Ornament*, London 1856, p. 5.
31 Lucien Magne, *L'Architecture française du siècle*, Paris 1889.
32 Meredith Clausen, *Frantz Jourdain and the Samaritaine: Art Nouveau Theory and
 Criticism*, Leiden 1987, pp. 61—69.
33 M.P. Verneuil, *Étude de la plante. Son application aux industries d'art*, Paris c. 1900,
 p. 1.
34 Verneuil, *Plante*, pp. 35—36.
35 Jones, p. 154.
36 Stuart Durant, *Ornament: A Survey of Decoration Since 1830*, London 1986, p. 27.
37 Mayeux, p. 41.
38 Auguste Racinet, *Polychromatic Ornament*, London 1877, p. 2.
39 J.A. Habert-Dys, *Fantaisies décoratives*, Paris 1886—87, e.g. plate 13.
40 Breidbach, 'Brief Instructions', p. 14.
41 Racinet, plates XXVII, IX.
42 Jones, p. 1.
43 Jones, p. 1.
44 Ernst Haeckel, *The Evolution of Man: A Popular Exposition of the Principal Points of
 Human Ontogeny and Phylogeny*, London 1879.
45 Philippe Thiébaut, 'La régression vers le végétal et l'aquatique', in P. Thiébaut (ed.),
 1900, Paris 2000, pp. 272—77.
46 Deborah L. Silverman, *Art Nouveau in Fin-de-Siècle France: Politics, Psychology, and
 Style*, Berkeley 1989, pp. 76—90.
47 See Bernard Marrey, *Les Grands Magasins des origines à 1939*, Paris 1979, pp. 173—83.
48 J. Le Guen, 'Le Nouveau Printemps', in *L'Architecte*, 1911, pp. 12—16.
49 Clausen, p. 71.
50 René Binet, 'Enseignement des Sciences. L'enseignement de l'Architecture à l'École
 des Beaux-Arts', in *La Revue Scientifique (Revue Rose)*, 4 April 1903, pp. 417—24.

Nature Ornamentation and Evolutionary Morphology

On the relationship between the artist René Binet and the biologist Ernst Haeckel

Olaf Breidbach, Jena

In his comprehensive history of ornamentation written around 1900, the Viennese art historian Alois Riegl outlined the evolution of artistic forms in which the "historic law of heredity and acquisition" had played a part.[1] It was not just that the forms of nature were directly taken over in the evolution of ornament. The principal point of interest was, in his view, that the laws of natural history organised on mechanical principles were continued in the evolution of decorative elements in the realm of culture. The details of the way Riegl's views can be reconciled with a general history of ornamental art have still to be explored. The debate goes back to an earlier nineteenth-century controversy about the importance of ornament in art. In Gottfried Semper's architectural designs, ornament became a key part of a work of art. It was no longer incidental decoration but a part of the building itself.[2] The evolution of ornamentation was thus no longer a mere appendage to the history of art but affected its very nerve system. This was particularly the case when, towards the end of the nineteenth century, there was wide support for the idea of basing an ornamental style on nature and expressing a sensibility for the forms of nature via the shapes of nature in a kind of simplistic Goethean morphology.[3]

The same consideration gives a whole new slant to the wallpapers of William Morris, which superficially look only like a consequence of feudal fruit and flower decoration.[4] Assuming that appreciating natural beauty means incorporating it in our culture, the forms of nature are not just incidental to, but are in fact primeval forms of, art. In the mid-nineteenth century, as the decorative element gained importance and new forms of art reproduction began to be used, especially in book illustration, Morris's ideas developed special significance.[5] With the steady increasing output of design handbooks, the 1860s witnessed the first attempt not only to depict and

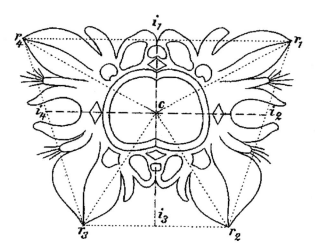

The illustrations in this essay have been taken from:
Ernst Haeckel's *Generelle Morphologie der Organismen*, 1866, plates 1 and 2

27

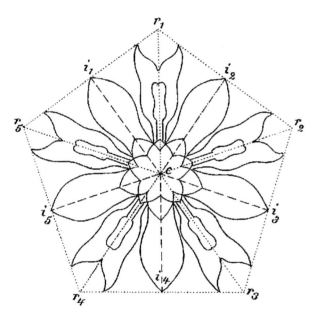

transform nature into art but to look directly for 'pattern books' of possible forms of ornament in it.[6] Such an ornament-minded view of nature was perhaps only possible in a society whose culture was developing most visibly in urban areas and in its immediate environment had somehow lost contact with *natura naturans*, which a late eighteenth-century German natural philosopher had still been able to locate somewhere in Saxony. For a cultivated person around 1900, nature meant what was available as decoration. Wild animals could be experienced in menageries. The only nature people still experienced was nature tamed. Nature no longer formed part of the structure of urban culture as a superior power but only as an optional and ultimately alien area of cultural experience.[7] Nature as seen in the zoos was not simply a slice of nature from remote bio-geographical regions, it was a controlled nature thrust behind the bars of culture. Depicted in its cage the creature was not only illustrated but showed at the same time that this alien element was dominated by and a captive of the viewer's own culture.

This was the climate in which a 'new naturalness' developed that provided a link back to nature — which as such was no longer accessible to experience — in natural visual patterns that constituted a sort of second evolution.[8] It was in fact a view of nature seen through an academic filter, the shape of nature as expounded by science and presented by it as an experience of nature.

In this 'new naturalness', the ornamental element gained new importance. Nature meant ornament, and according to a natural scientist like the biologist Ernst Haeckel it was revealed only in the beauty of its symmetrical configurations. How seriously René Binet took this 'new naturalness' of ornament can be seen from his design for the entrance gateway to the Exposition Universelle in Paris. It represents the skeleton of a radiolarian — the single-celled creature described in a Haeckel monograph — blown up to gigantic proportions; visitors passed through it to enter the exhibition. The decorative element has become the architecture. It is no longer stuck on but represents itself, in accordance with pre-existent new naturalness.

The cultivation of nature in Binet clearly goes a step beyond the theoretical confines set out by Riegl. In the present newly reprinted volume of the *Esquisses décoratives*, Binet explains the diversifications of ornamentation based on natural forms. The starting point of his experiments with form is Haeckel's visual representations of nature. From these, as he shows in the first pages of his work, he develops a complex range of patterns. He takes over not only the images of the living forms but also Haeckel's broader theory of a nature that is symmetrically organised in the individual specimen. The ornaments he derived from his study of Haeckel's natural forms seem to run through variations of a pre-determined basic pattern

depending on different types of application, in the manner of a biological radiation.

The starting point of Binet's evolution of forms is no longer the observation of nature by an artist but a scientific image. The decorative element is no longer defined in accordance with nature itself but in accordance with the image of this nature as promulgated by the culture of the sciences. Binet himself did not sketch the forms of nature on which his depictions are based, but took them over from an academically proven expert source. This enabled him to open up new ranges of forms, as many of the shapes Haeckel illustrated are simply not available to ordinary observation. Some of them are for example tiny little organisms that can only be observed with a special microscope. Moreover, the habitat of a whole series of Haeckel's animal forms is the sea — in some cases, deep sea, which is quite out of reach for the average observer.[9]

The forms that Haeckel presents have a further characteristic. They are drawings shaped by the pattern of the perception culture of his day. Accordingly, they show nature as pre-digested into the perception forms of the artist who was using them. Though they were new, therefore, they were not alien, as they already looked cultivated. Indeed, as natural shapes they were ennobled by the natural historian. They were not simply individual observations, tiny grains of once living forms that an outsider might casually wipe from the specimen table like dust. Incorporated in a scientific representation, these minimal forms gained a dignity of their own. They were documentation of a scientific mind's study of nature that found system in them. Individual representations are not in fact just representations of specific individual specimens. They demonstrate general validity by means of these single specimens. The depictions of species thus contain formal types placed alongside each other. These produce a series of formal variations that Haeckel used to systematise nature, this systematisation being revealed to him in the ornamentation of the shapes. Ornamentation thereby gained a new dignity, since it was no longer viewed as a superficial add-on to a variety of natural specimens. It was exposed as a dimension that structured nature. The gradations of forms offered by Haeckel the natural scientist produced something like an artistically conceived essence of natural organisations. They manifested a (new) naturalness of their own reflected in culture,[10] which made nature available as cultural nature.

The product was thus an architecture of nature, a natural system matching the culturally evolved construct. The architecture was elaborated from a scientist's formal model whose perception was governed by a sense of aesthetics oriented towards the ornamental. The series of symmetries he set out were affected by perceptional predispositions in which nature was culturally determined at the

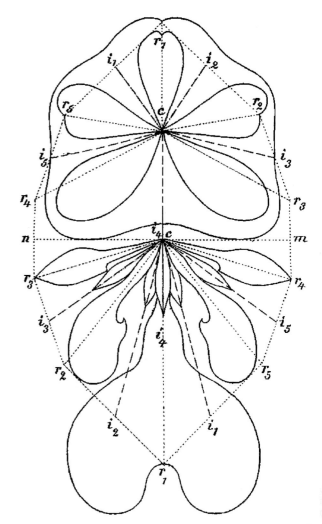

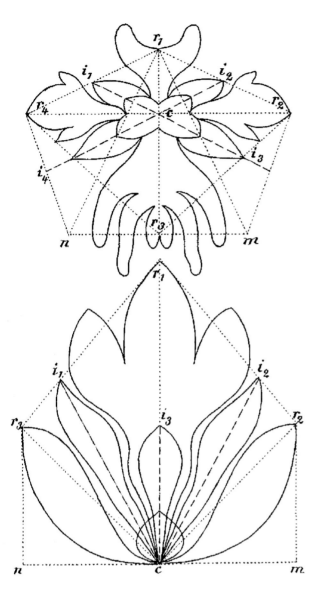

level of its first representation by science. For a scientist whose perception was culturally minded, the diversity of forms was, inasmuch as they were visible in the first place, derived from the regularity of their structural propensities. A kind of aesthetic was thereby produced that — without any knowledge of physiology and patterns of behaviour — placed given natural forms in a specific relationship with other forms from the first moment of observation. As is described in Haeckel, the depiction of relations of symmetry allowed this variety of forms to be recorded within a uniformly structured pattern of observations. For the scientist building on this view, laws could then be found in which structural diversity could be understood and articulated as variations of a formal structure. This variation would then be nothing but the 'etching of ornamentation', as an evolutionary biologist calls the fanning out of variants of related life forms in time.

But how does such a derivation of laws of structural predisposition stand up at the level of scientific research? Could a structural law really be found here that used mere observation as a basis for a system representing more than superficial relationships of similarity? For Haeckel, observation guaranteed knowledge. Accordingly, representing the symmetrical relationships in nature meant understanding nature. For Haeckel, natural order — and the genealogical relationships between various forms of nature — could be understood via the obvious relationships of similarity between natural forms.

In the first chapter of his *Generelle Morphologie der Organismen* (General Morphology of Organisms), one of the pioneering works of evolutionary theory in the nineteenth century, Haeckel wrote: "The morphology of organisms is the whole science of the internal and external formal relationships of living natural bodies, animals and plants, in the broadest sense of the word. The task of organic morphology is consequently to understand and to explain these formal relationships."[11] Morphology is thus a representation of variations of symmetrical relationships. It corresponds here to the theory of ornamentation that Riegl sought to describe in his draft of 1893, nearly thirty years after the appearance of Haeckel's *Generelle Morphologie*. But the formal characteristics in which the series of forms could be placed in a row were there for the natural scientist to discover, as they had already been for Haeckel: "The combined effect of a wide variety of branches of natural science, which for example has brought physiology to such an impressive level in the last decade, is of service in morphology only to a very minimal extent. And the infallible mathematical certainty of the measuring and calculating method that has raised the morphology of inorganic natural bodies — crystallography — to such a high degree of perfection is applicable in the morphology of organisms almost nowhere."[12] Haeckel wanted to change this state of affairs: "Only if the laws of

their formation can be developed out of the colourful chaos of shapes can the inferior art of morphography be transformed into the sublime science of morphology."[13]

The representation of the laws of formation supplied him with a picture in which the formal diversity of natural specimens could be structured. This kind of structuring, where relationships of similarity are identified and diversity is arranged in an orderly system, offered the desired regularities or laws. Thus for Haeckel a law was a function in which relationships of similarity identified during study could be formally expressed. Through it the principle of the system was formulated whereby a diversity of details could be tidied into a connected context. Thus arrayed in a series, the individual forms of life could be interpreted as elements of a whole. If the system behind this whole could be made visually obvious, it would, Haeckel considered, also be comprehensible. Once rendered visual, the systematics of nature would be accessible. In this rather naïve view, the regularity perceived contained its own explanation.

For Haeckel, such regularities consisted of gradations of symmetrical relationships between individual forms, the symmetries being simply understood as increasingly complex variants of mirror symmetries. Kaleidoscopes are perhaps one of the most comprehensible versions of such mirror symmetries. They render a simple picture more complex by using a large number of ingeniously arranged mirrors. The arrangement of mirrors is such that the initial picture becomes a part-section of a visual space that just repeats the original section several times. Shaken up into no apparent order, the stones or other tiny shapes in the original picture of a kaleidoscope no longer appear in the repetition of their position as the result of a purely random scattering. In the repetition of the picture, what is seen now appears necessarily so. The regularity of its position thus makes a rule visible. The mere multiplication of a structure generated purely accidentally produces order. Moreover, this order acquires a gradation that, starting with simple duplications, allows more and more complicated reflections that, as a sequence, can then be reconstructed as a series.

The symmetry — order made visible — acquires particular importance for a natural historian who takes the diversity of forms not as the constantly recurring reaction of nature but as the distillation of (evolutionary) history. Order in history is after all proof that the historical process is not completely random but makes an inner structure visible.

However, Haeckel was one of the principal representatives of Darwinism, the theory of natural history that dominated the second half of the nineteenth century. According to Darwin, though natural forms are the result of a historical process, they are uncontrolled and therefore random. In its succession of forms, such a process is

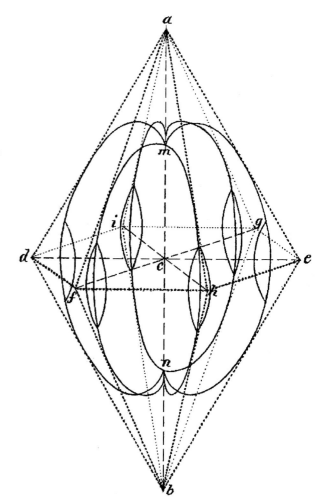

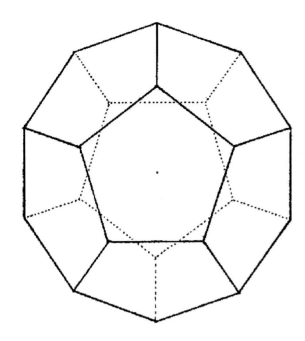

however nonetheless also oriented to the genealogical series it comprises. A form that features as part of such a series carries a particular disposition that cannot be simply negated by the subsequent development. If it is, the form becomes extinct. But if its evolution continues, this always builds on what already exists. Individual elements of the starting form are adopted in the next stage of evolution and developed further.

In this view, the order or system of the forms can be worked out by looking at it. What then unfolds to the observer is a kind of organic crystallography, one in which he sees the structure of natural forms summed up visually. For Haeckel, the aim was thus to describe a common principle of how nature was structured in evolving from the simple crystal to the most complex organism via the various formal variants.[14] The step-by-step, successive manifestation of natural ornamentation was reflected in the symmetry of the forms. In this, the individual ornament represented the individual natural form, which was integrated into the totality of natural design as an ornamental part.

Haeckel described several crystal systems that could serve to classify the variety of natural forms: "These are important for our comparative study of inorganic bodies and organisms because they determine the basic geometrical forms of a number of protists, especially radiolarians, with the same regularity."[15] According to him, complex forms evolved like the forms of an ever more complex ornament, by the addition of various basic forms. "Numerous individuals join in a row like the links in a chain or a string of pearls."[16] If the arrangement of such simple forms became complex, said Haeckel, "deformations" arose by means of which both organisms "of tissue-forming plants and animals" and more complex crystal formations could be described. What was conspicuous thus itself demonstrated a law that could be observed as structure in the context of the system.[17] This system was produced in the succession of symmetries, so that the design of nature was unmasked as ornament. Nature as such was the process of genesis of natural forms that gave rise to a succession of generations in their evolution, which were then available for study as a constantly evolving line of diverse ornaments.

In the process, these ornaments display in the symmetries that constitute them an increasing degree of complexity as they evolve. When their successive forms are depicted, the gradations are revealed that progress from simple to advanced. A hierarchy develops in this gradation to the extent that enables biologists to identify a succession of genealogical units. There are basic forms whose variation explains a structural diversity in which the more complex forms are seen as the result of a real evolution. In this, more complex organisms are seen not as single forms but as composites of diverse series of forms. Such series of forms can be described by means of

the structures of different tissues making up a complex organized animal or plant. To this extent, the individual can be depicted within a 'theory of the constitution of the body from unequal parts.'[18] To the scientist proceeding according to this approach, the prospect opens up a succession of ornaments differentiated in many ways, in which the morphology of nature can be represented. The fact that all these diversifications of forms can be interpreted as variations of a simple structuring principle, makes this nature valid as reality. Analogous to a crystallography of the inorganic, there is a crystallography of the organic. The structuring principles identified there make natural design as such accessible. At the same time, the succession of refractions of symmetry can be reconstructed in pictures of nature. As a succession, the series can be understood as genealogy. Consequently, the structuring of a natural kaleidoscope can be described as a sequence of successive events — a process. The individual link in this process is — as already said — immaterial. It is only defined as an element in the process. To this extent, an individual specimen of this kind is, like an ornament, something that has an effect not in its details but in its structuring as a whole, as a natural design. The study of natural forms reveals the individual caught in a process of evolution, a vital natural process, but one whose expressions are only visible as ornament.[19]

A realm of symmetries is thus constructed in the study of natural forms. For Haeckel, the visualisations he developed from the constantly refracted constellations in his studies made visible the history of a continually adapting nature. Haeckel saw nature as an endlessly evolving crystal. [20] Binet managed to make direct use of the images that this theory produced. As his correspondence with Haeckel shows[21], Binet also absorbed the principles of Haeckel's aesthetic of nature.

1 Riegl, A., *Stilfragen. Grundlegungen zu einer Geschichte der Ornamentik.* Berlin 1893, p. VIII.

2 Cf. Gnehm, M., *Stumme Poesie. Architektur und Sprache bei Gottfried Semper.* Zurich 2004; Oechslin, W., *Stilhülse und Kern. Otto Wagner, Adolf Loos und der evolutionäre Weg zur modernen Architektur.* Zurich 1994.

3 Cf. also Breidbach, O., DiBartolo, M., Vercellone, F., 'La seppia e il sublime. Sulla naturalizzazione dell' estetica contemporanea'. *Estetica* 2, 2004, pp. 5—32.

4 MacCarthy, F., *William Morris: A Life for Our Time.* London 1994.

5 Cf. Timm, R. (ed.), *Die Kunst der Illustration. Deutsche Buchillustration des 19. Jahrhunderts.* Weinheim 1986.

6 Cf. Breidbach, O., *Visions of Nature. The Art and Science of Ernst Haeckel.* Munich/ Berlin/London/New York 2006.

7 Dittrich, L., Engelhardt, D. von, Rieke-Müller, A. (eds.), *Kulturgeschichte des Zoos.* Berlin 2001.

8 Cf.: Breidbach, O., 'Neue Natürlichkeit?' In: Breidbach, O., Lippert, W. (ed.), *The Nature of Things.* Vienna/New York 2000, pp. 6—26.

9 Haeckel, E., *Kunstformen aus dem Meer: der Radiolarien-Atlas von 1862.* Munich 2005.

10 Hoppe-Sailer, R., 'Der Biologe als Ästhet. Ernst Heinrich Haeckel.' In: Loth, W. (ed.)
 Wissenschaftszentrum Nordrhein-Westfalen/Kulturwissenschaftliches Institut —
 Jahrbuch, Essen 1994, pp. 162—79.

11 Haeckel, E., *Generelle Morphologie der Organismen*. Berlin 1866, vol. 1, p. 3.

12 Ibid., p. 5.

13 Ibid., p. 7.

14 Breidbach, O., 'Anschauliche Naturordnungen — Bemerkungen zu Ernst Haeckels
 Studien über die Kristallseelen.' In: Stahl, C. (ed.) *Lebendiger Kristall*. Ostfildern-Ruit
 2004, pp. 25—33.

15 Haeckel, E., *Kristallseelen. Studien über das anorganische Leben*. Leipzig 1917, p. 3.

16 Ibid., p. 5.

17 Ibid., p. 6.

18 Haeckel, E. op. cit. 1866, vol. 1, p. 25.

19 Ibid, p. 400.

20 Cf. Breidbach, O., *Visions of Nature. The Art and Science of Ernst Haeckel*.

21 Hossfeld, U., Breidbach O. (eds.), *Haeckel Korrespondenz: Übersicht über den
 Briefbestand des Ernst-Haeckel-Archivs*. Berlin 2005.

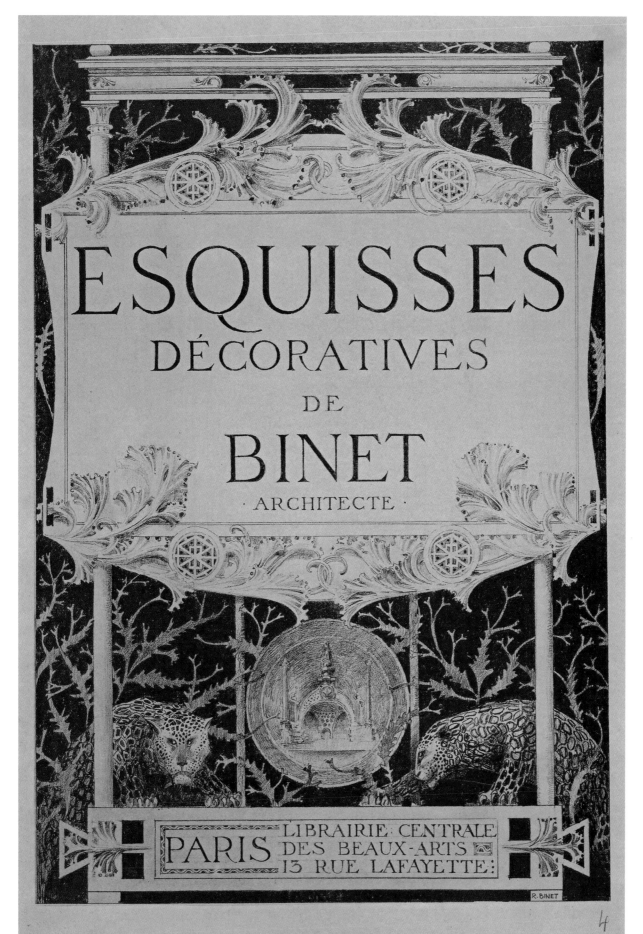

ESQUISSES

DÉCORATIVES

DE

BINET

ARCHITECTE

PARIS LIBRAIRIE·CENTRALE
DES·BEAUX-ARTS
13·RUE·LAFAYETTE:

R·BINET

4

Ernst Haeckel.

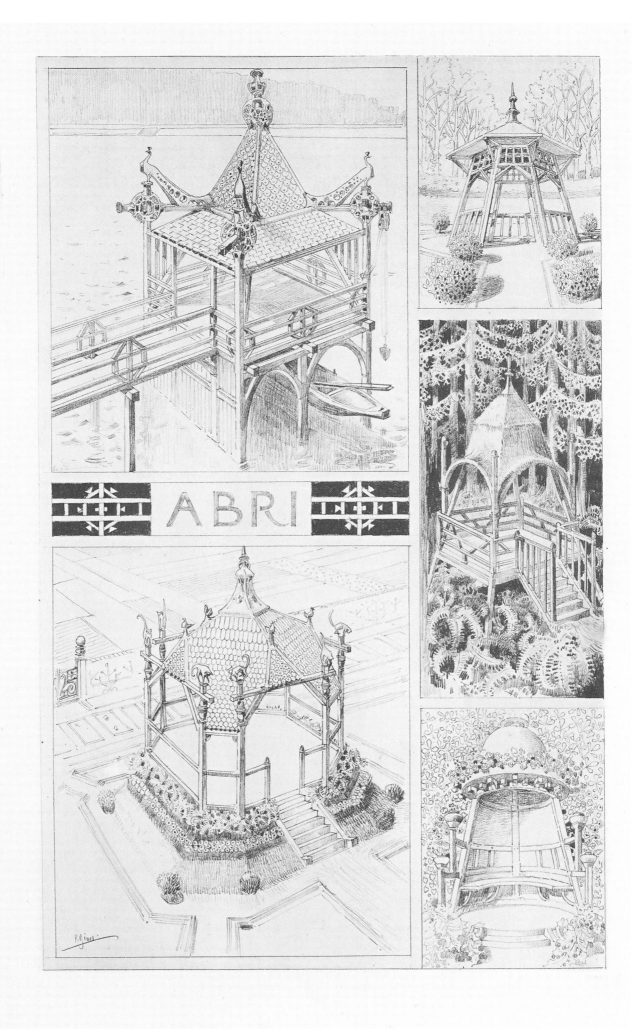

Abri — Shelter

AGRAFE

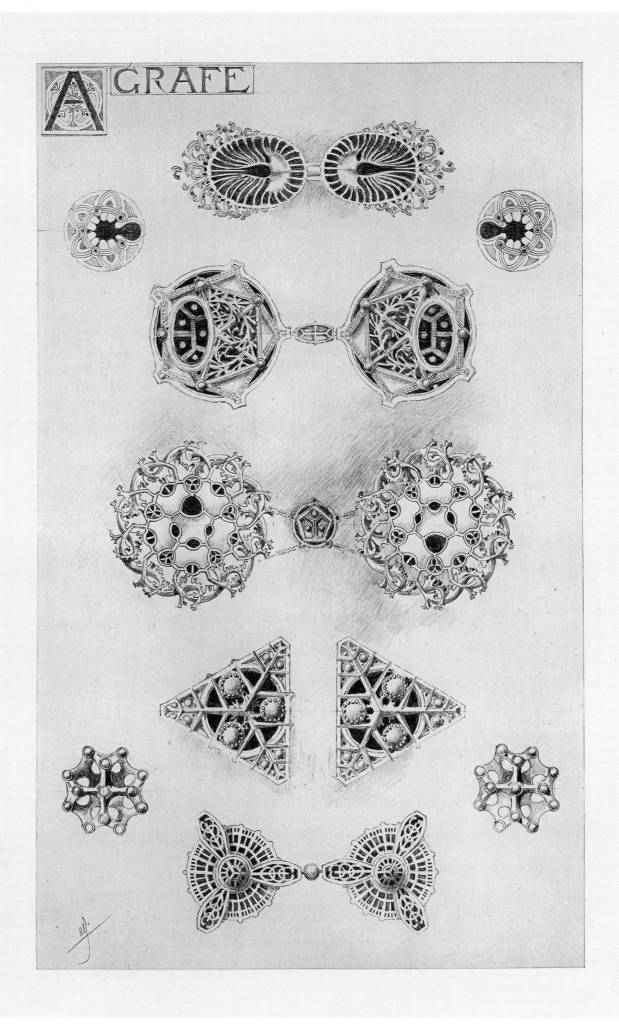

Agrafe – Clasp

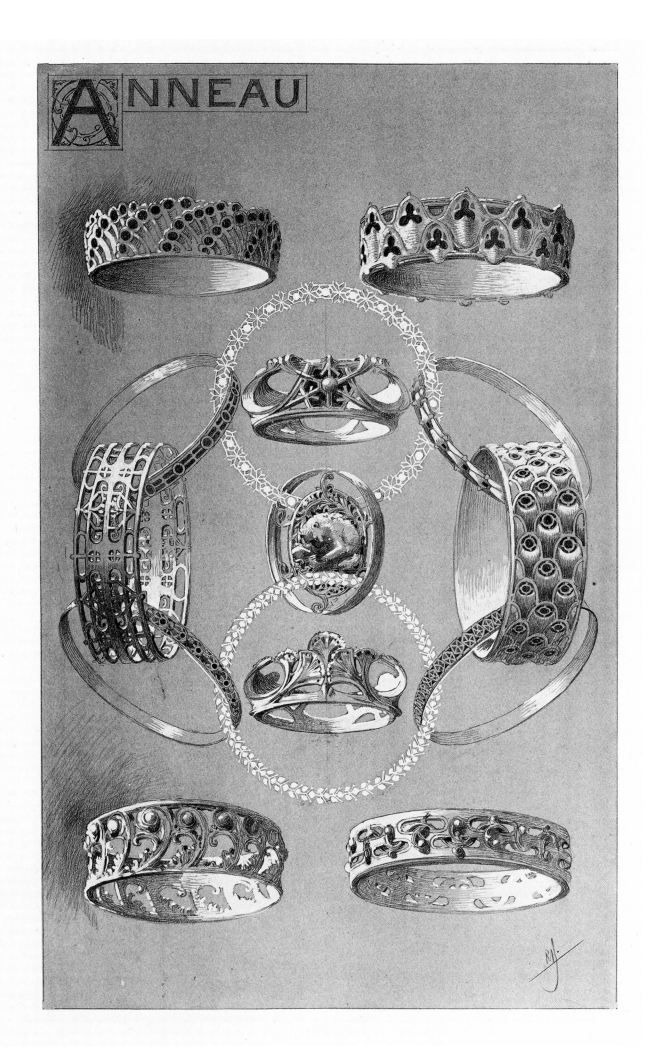

Anneau — Ring

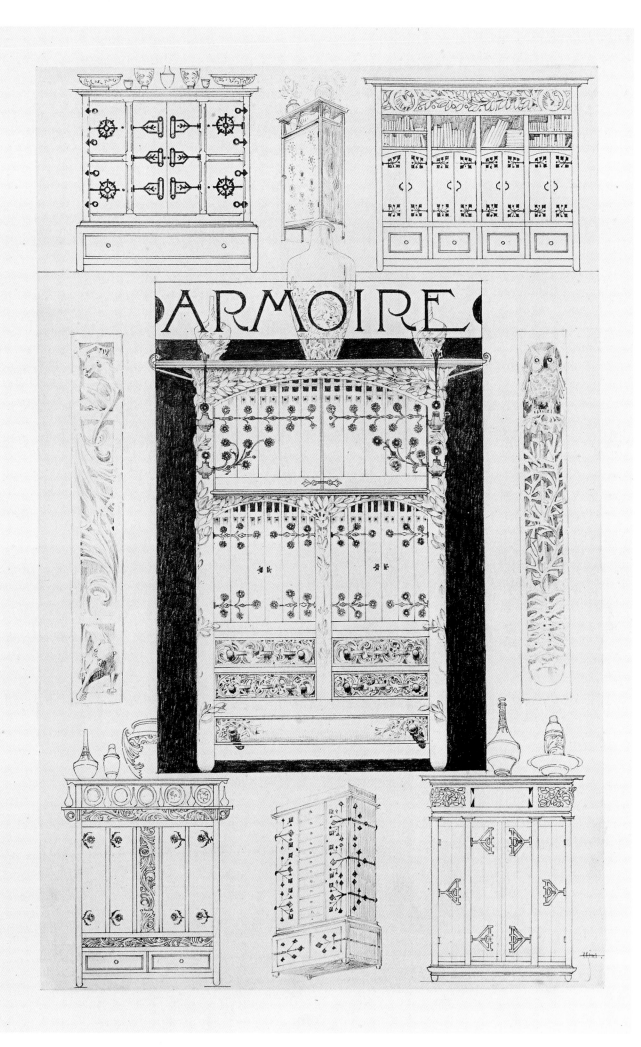

Armoire — Cupboard

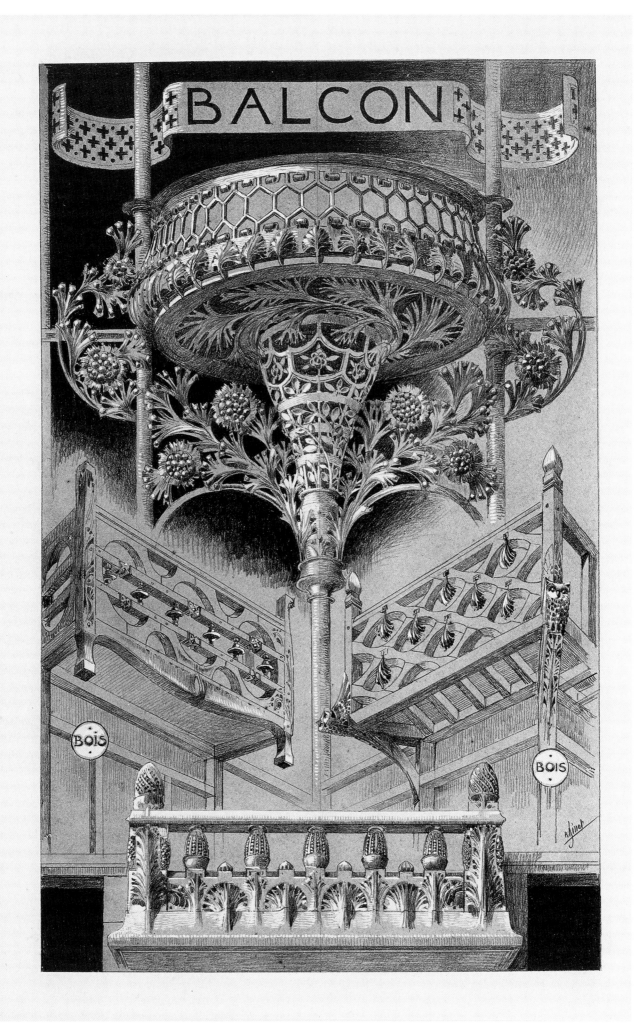

Balcon — Balcony

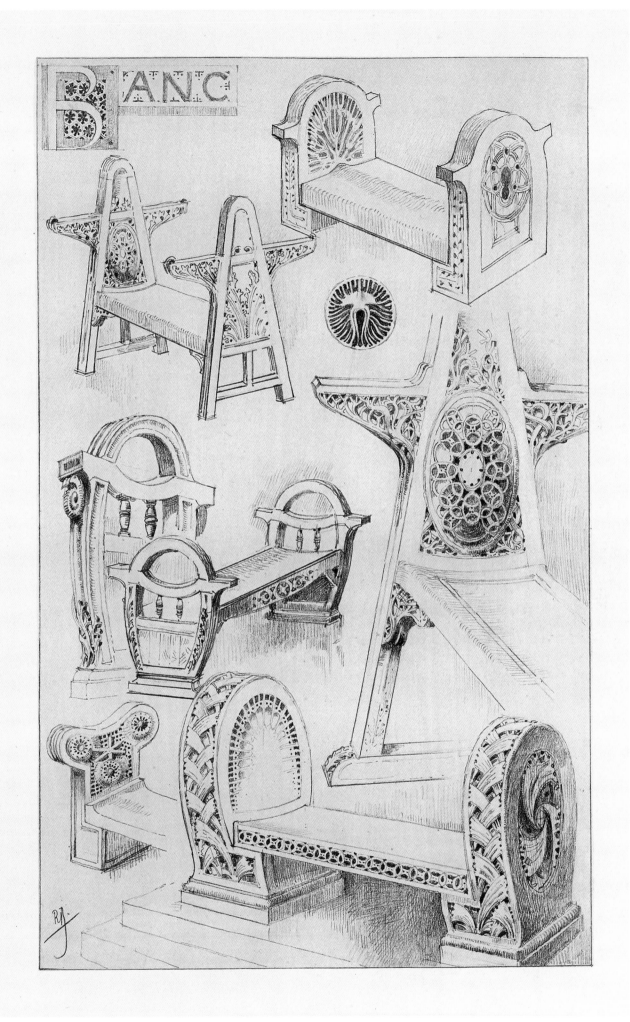

Banc — Bench

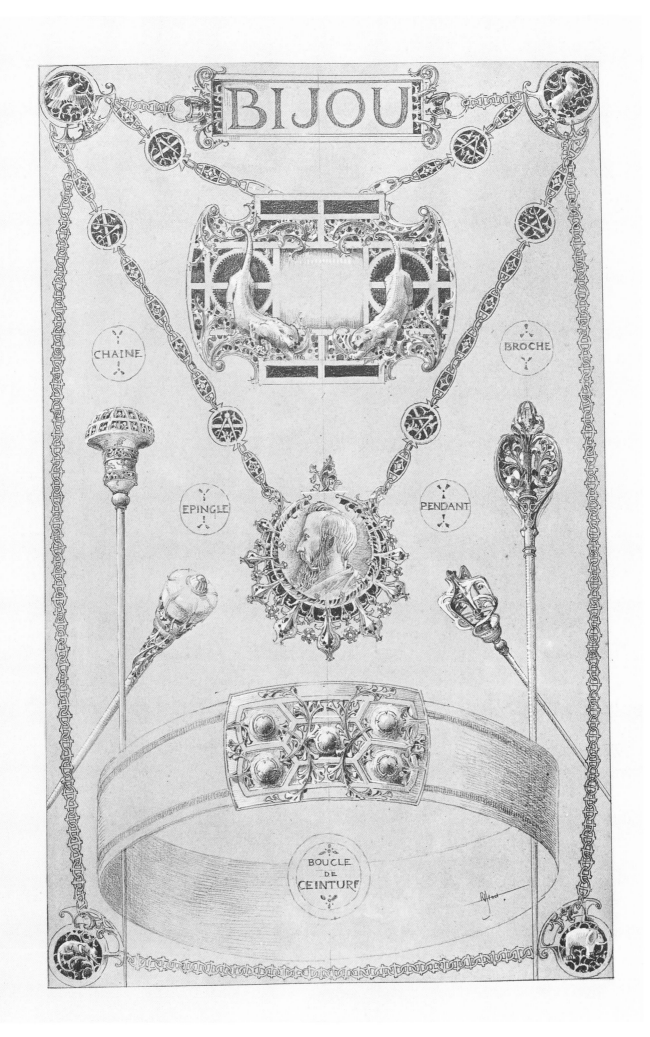

Bijou — Jewellery

Bordure encadrement — Framing

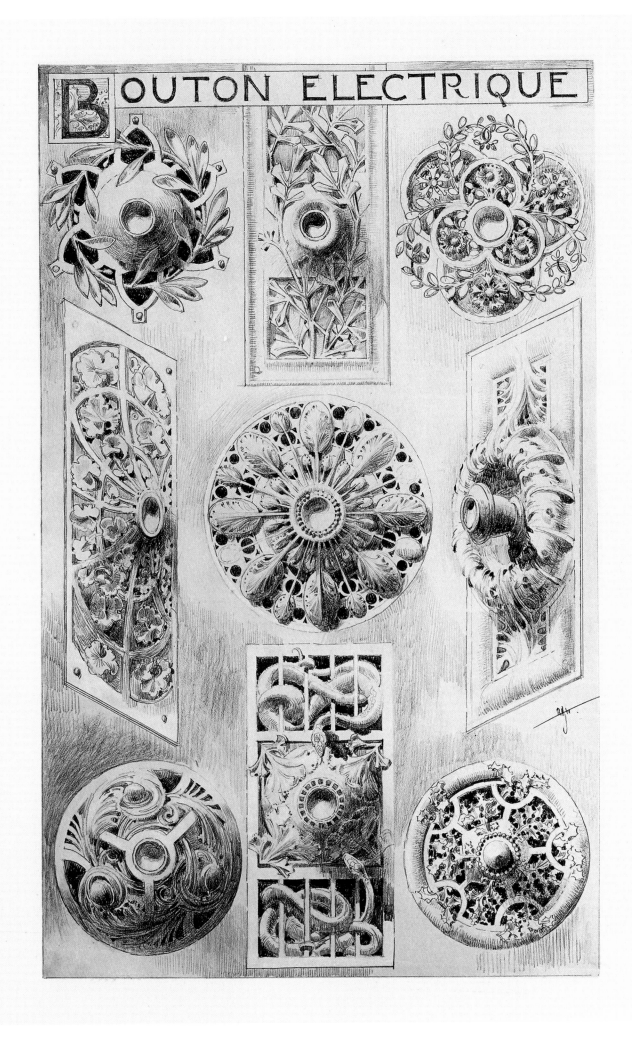

Bouton électrique — Electric button

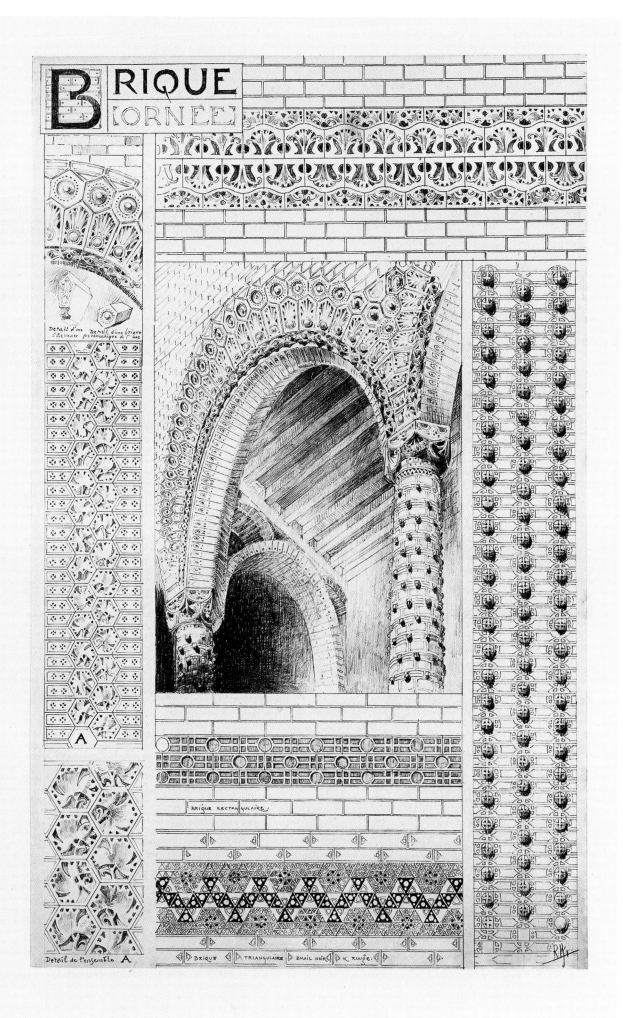

Brique ornée — Patterned brickwork

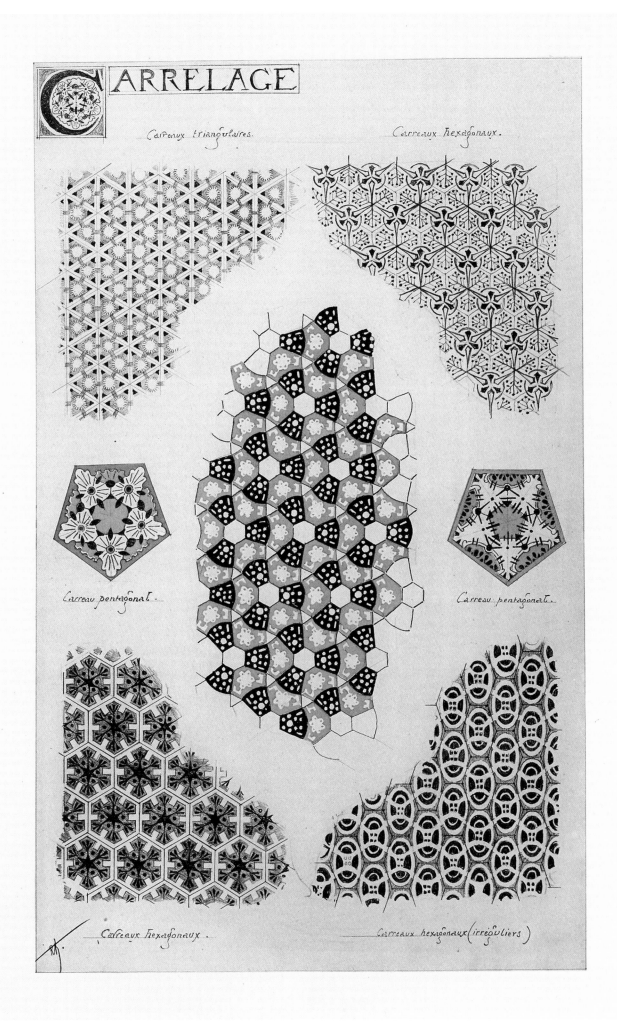

CARRELAGE

Carreaux triangulaires.

Carreaux hexagonaux.

Carreau pentagonal.

Carreau pentagonal.

Carreaux hexagonaux.

Carreaux hexagonaux (irréguliers)

Carrelage — Floor tiles

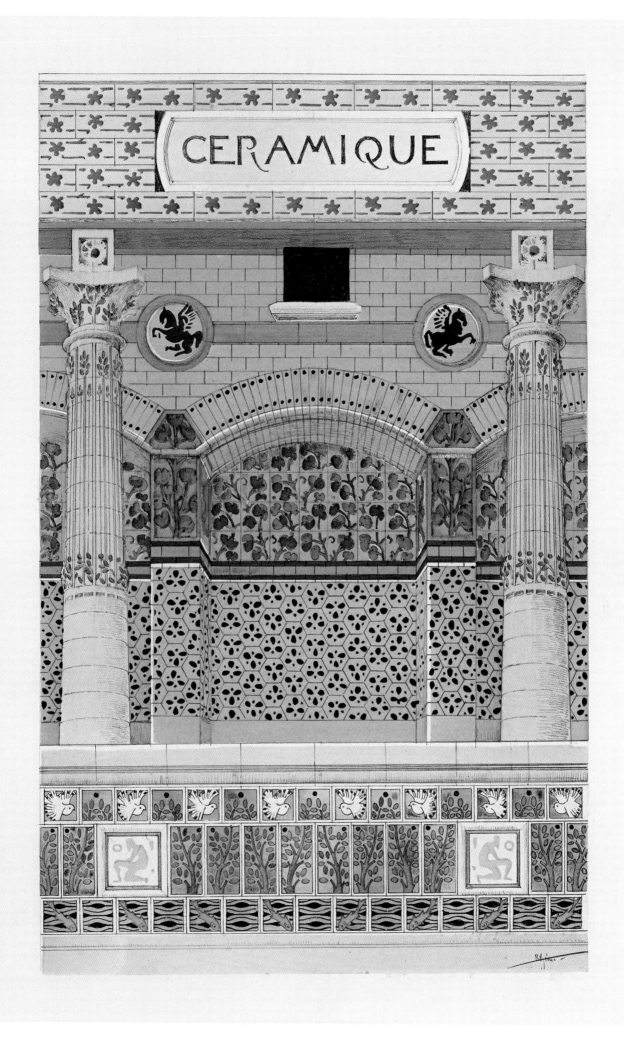

Céramique — Ceramic

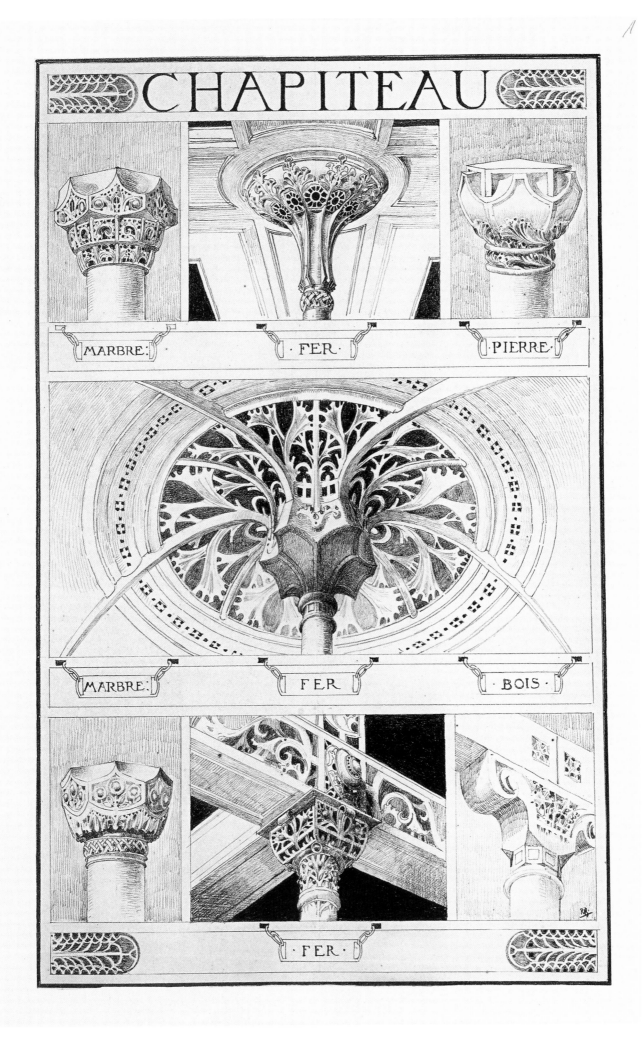

CHAPITEAU

MARBRE: · FER · PIERRE ·

MARBRE: · FER · BOIS ·

· FER ·

Chapiteau — Capital

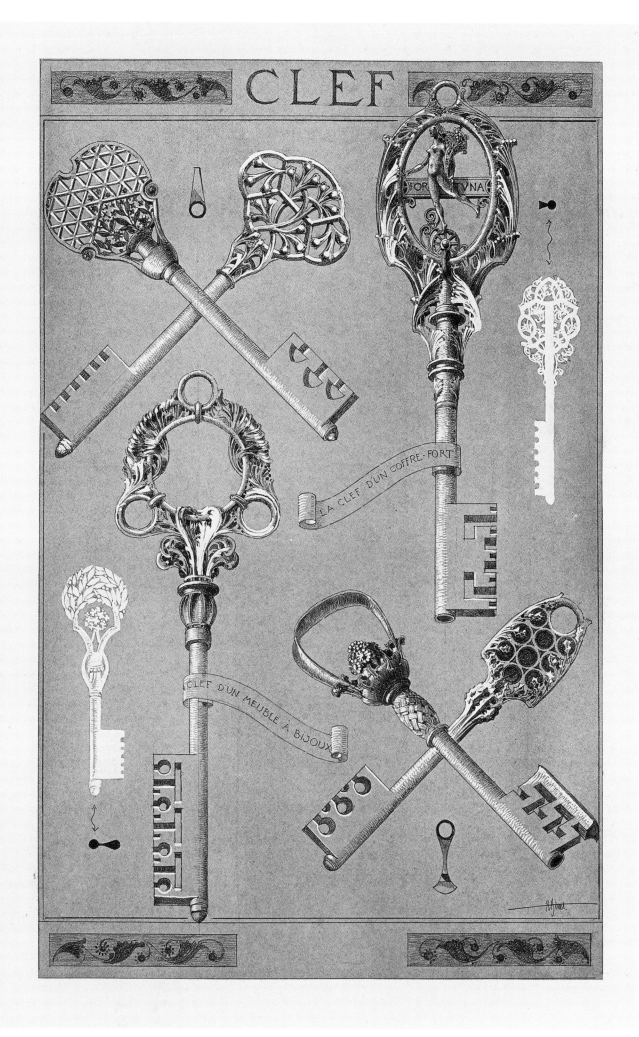

Clef — Key

Clôture bois — Wooden fence

Clôture grillé — Ironwork fence

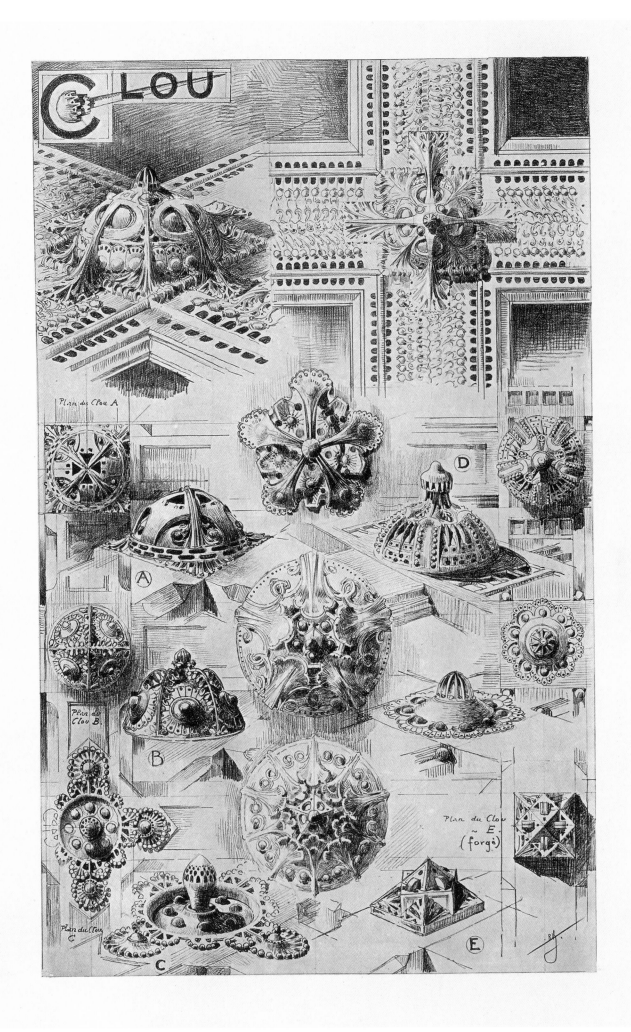

Clou — Boss

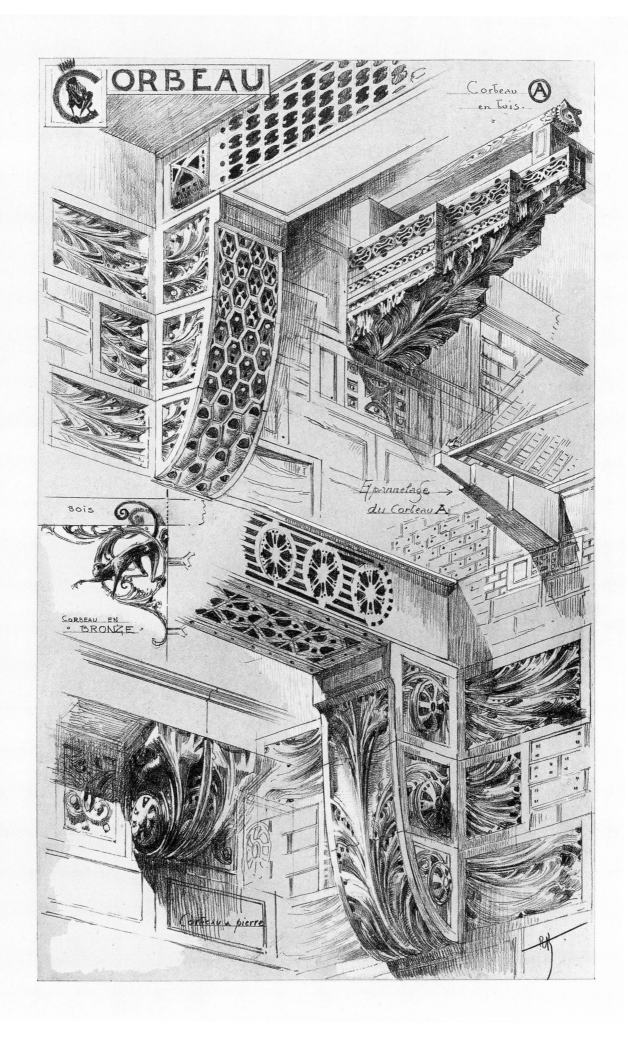

Corbeau — Corbel

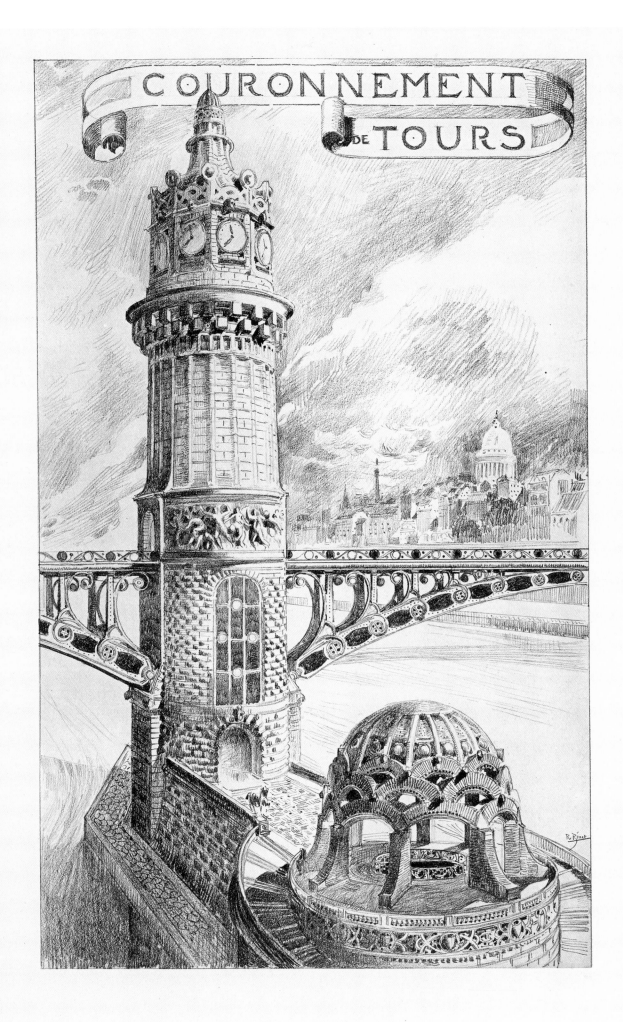

Couronnement de tours — Tower crown

Décor champêtre — Rural decor

Enseigne — Sign

En A epi primitif :
Plante dans un pot posée sur
une planchette fixée au poinçon.

En B, ensemble de la
crête d'une toiture avec les
2 Épis dont le détail est
en C

F

A

B

B

C

Détail de la
partie supéré
d'un poinçon
sur lequel
pourraient
s'assembler

Les epis
C.
& D.

Assemblage
& des 4
pour recevoir

d'un poinçon
à rétiers
l'épi F

Plan

D

Plan

Détail de la partie
Supérieure de l'Epi
C

Détail de
feuilles de
l'Epi F

Epi dérivé du croquis

A

Epi — Pinnacle

Escalier — Staircase

Étoffe imprimée – Printed fabric

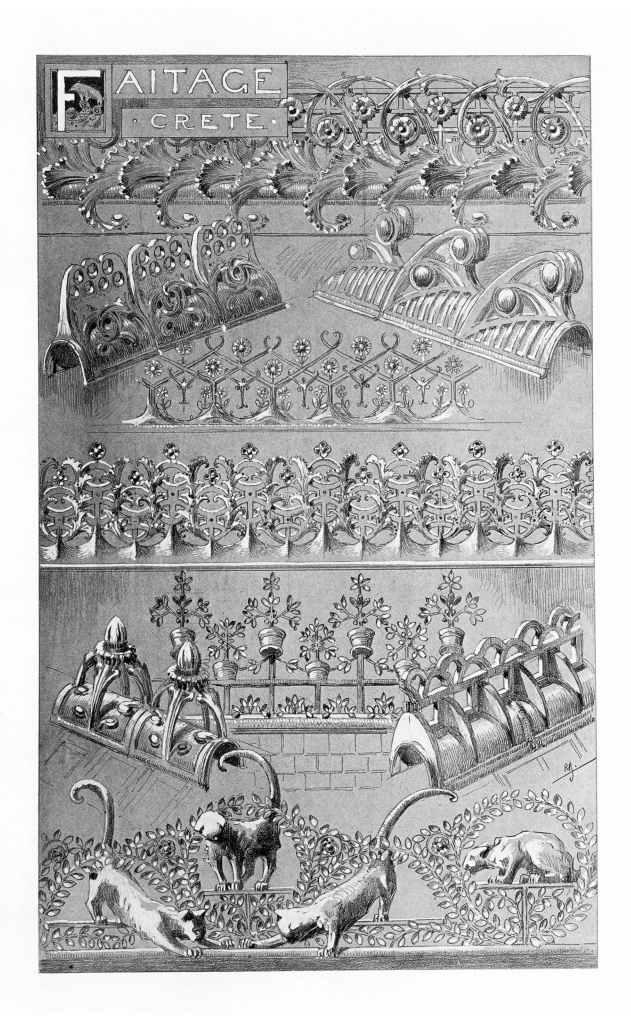

Faîtage crête — Roof ridge

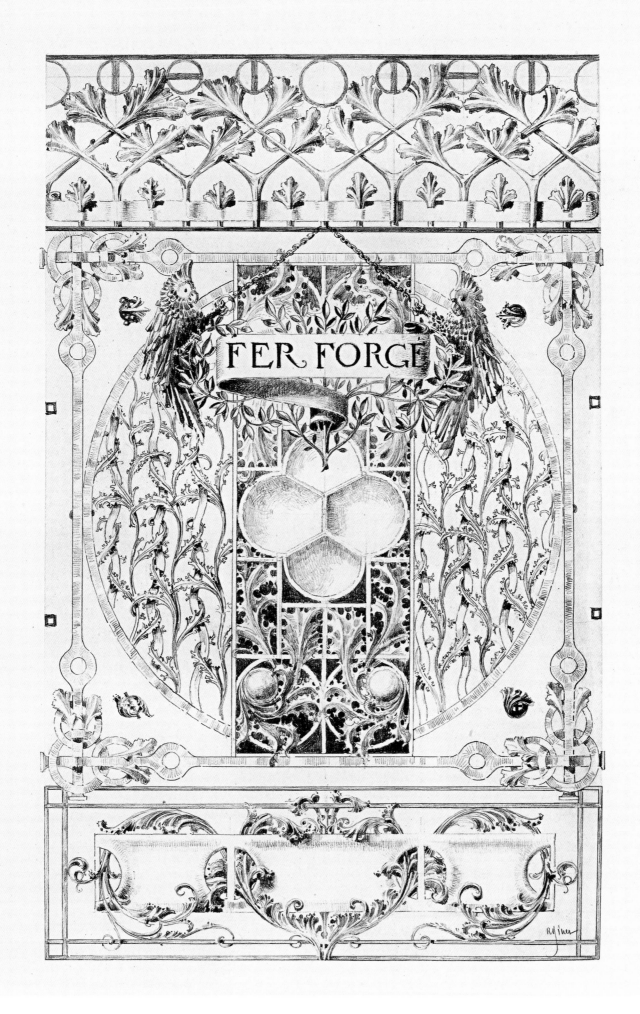

Fer forgé — Wrought iron

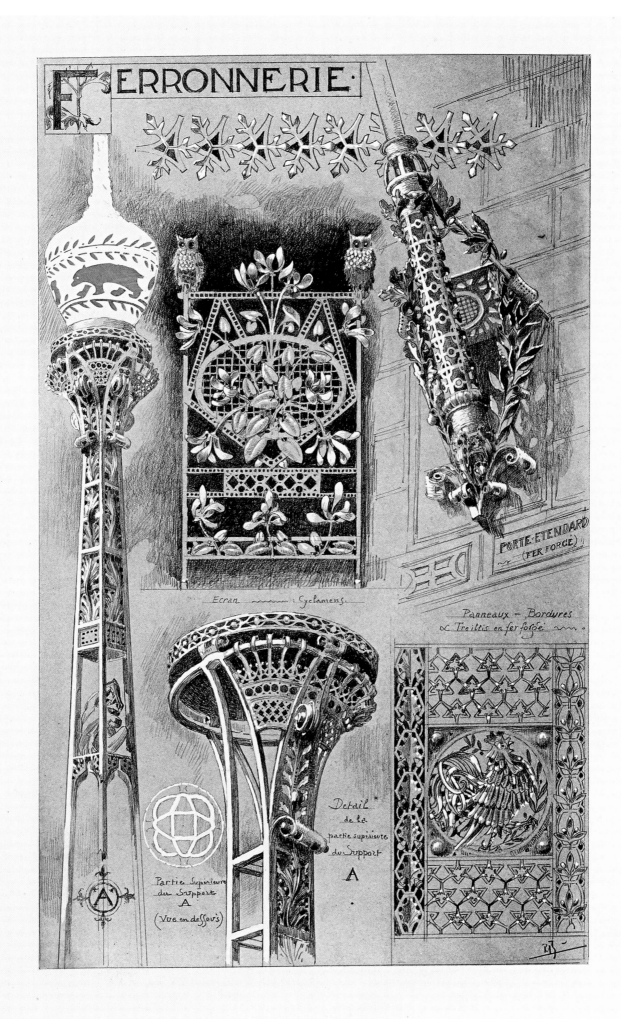

Ferronnerie — Wrought-iron work

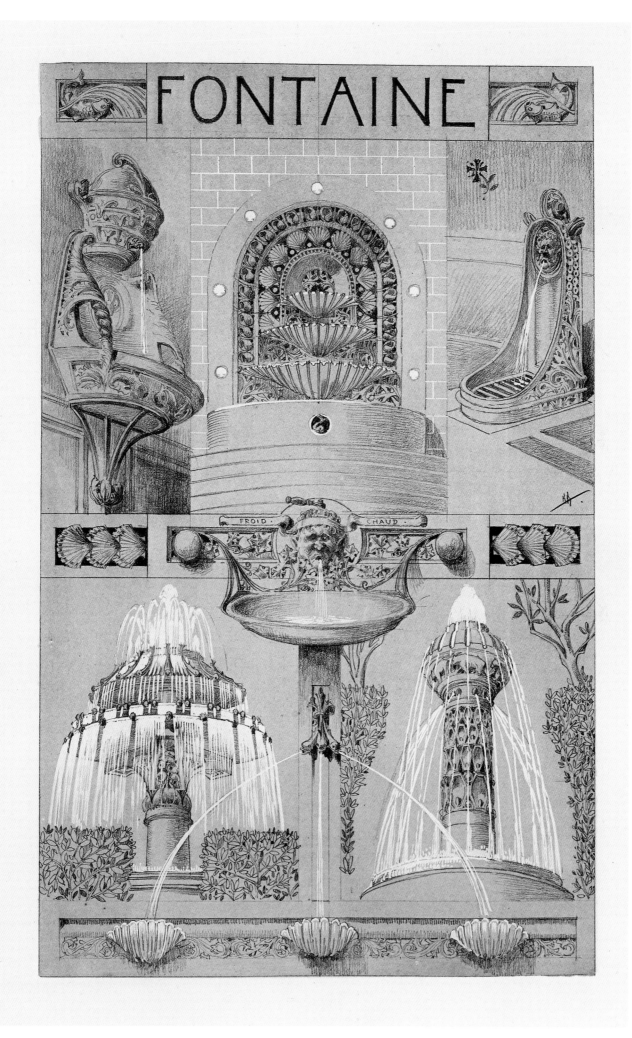

Fontaine — Fountain

Frise — Frieze

Girouette — Weather vane

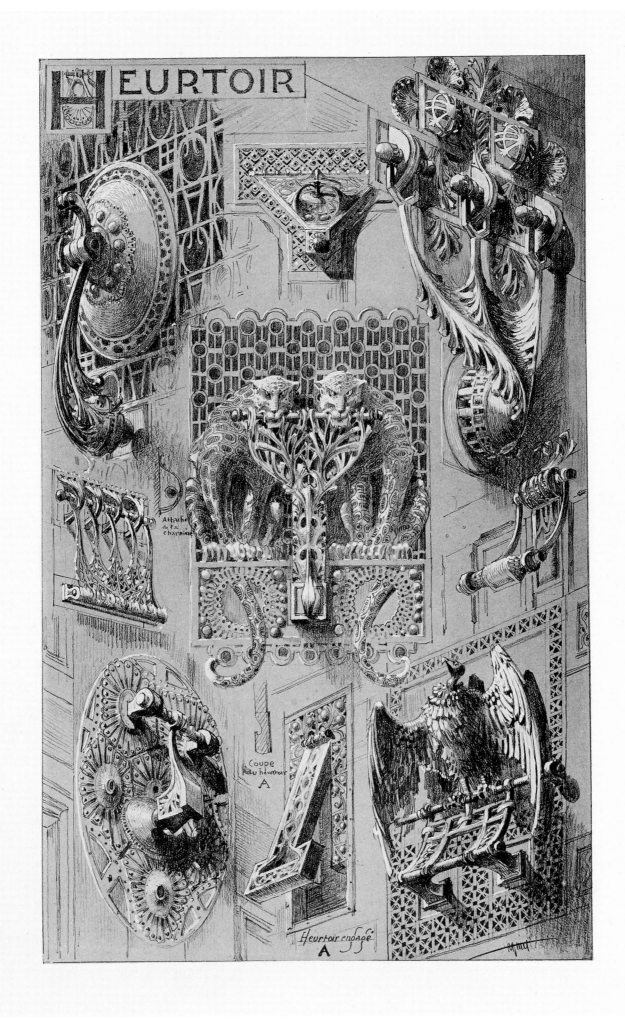

Heurtoir — Door knocker

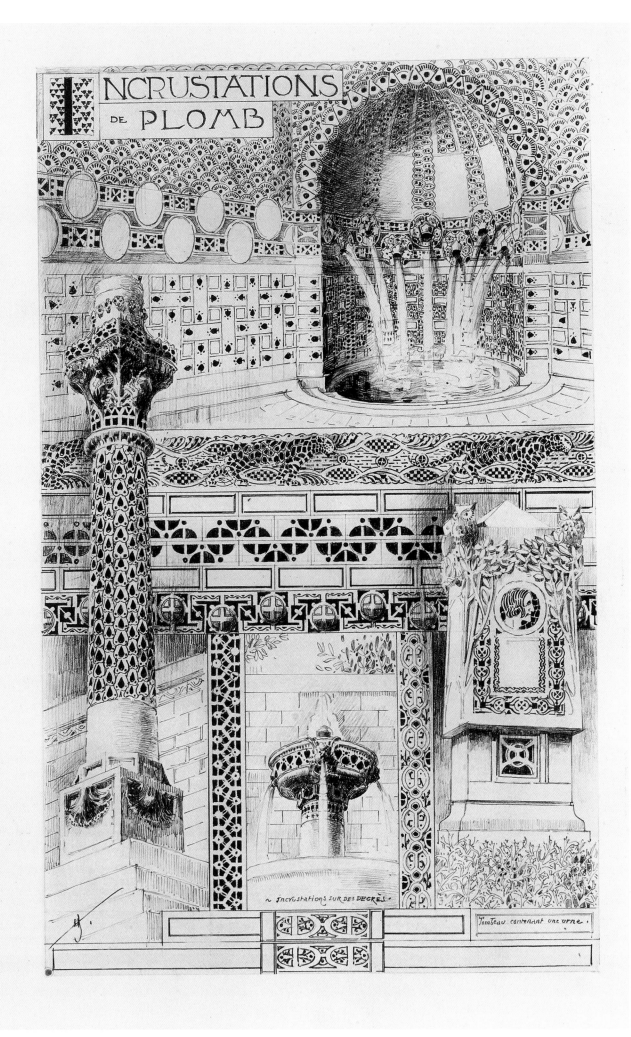

Incrustations de plomb — Lead inlay work

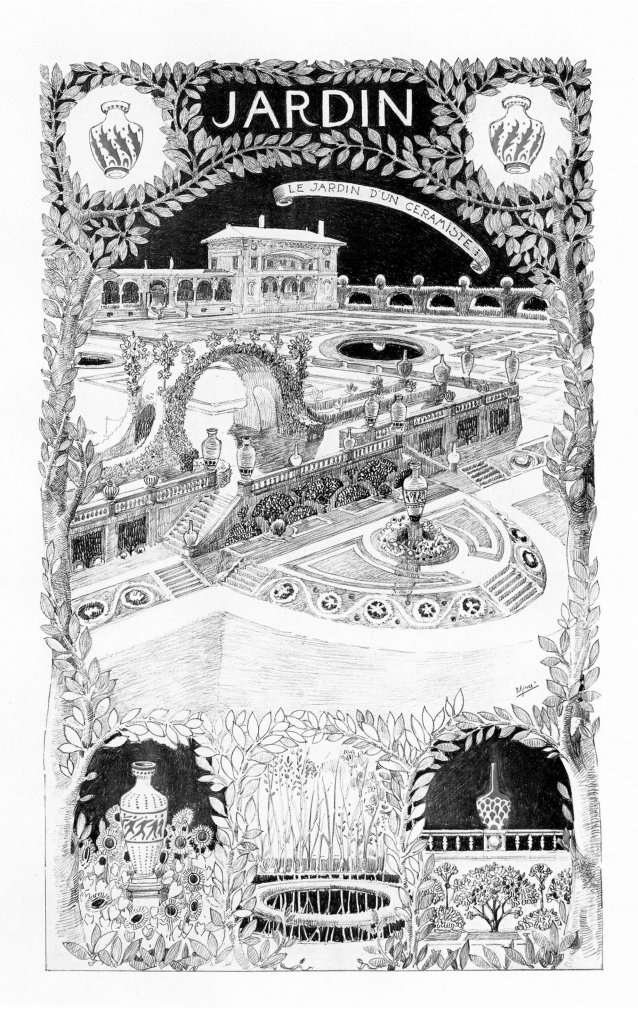

Jardin — Garden

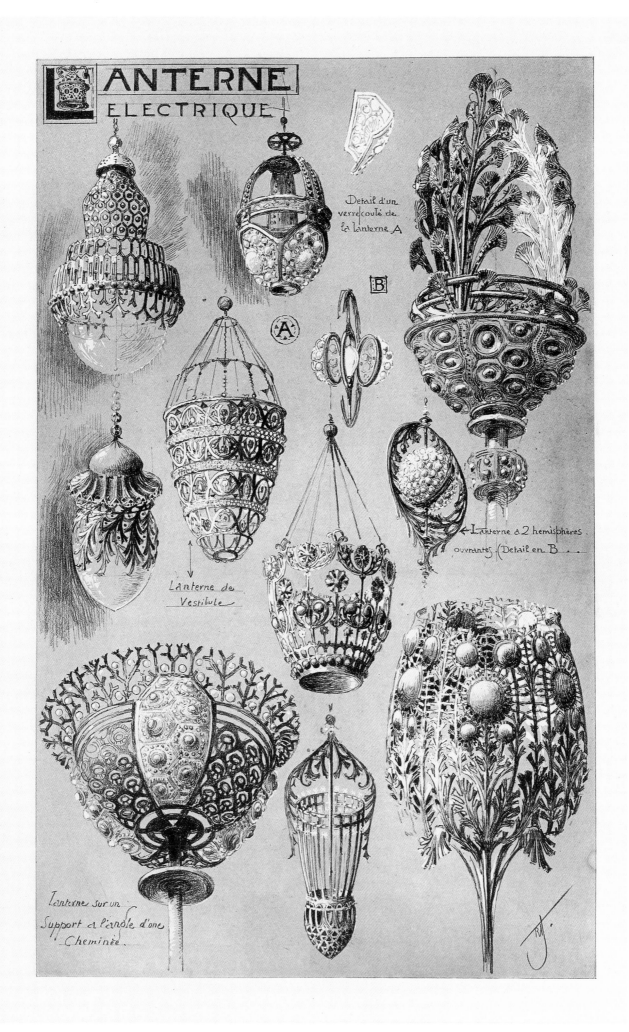

Lanterne électrique – Electric light

Lustre, Vitrine, Applique — Chandelier, Display cabinet, Decoration

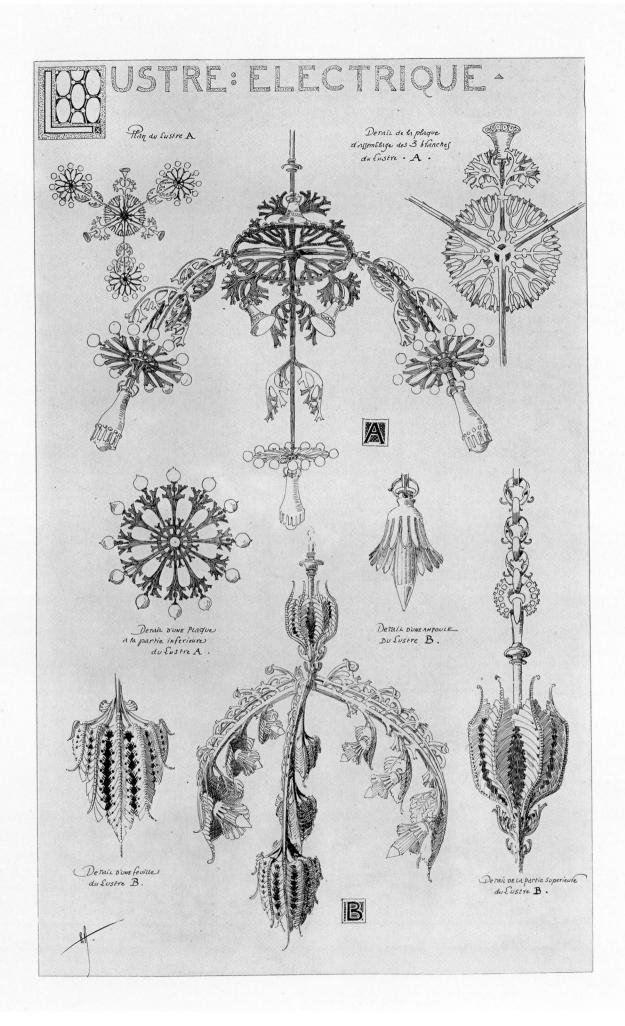

Lustre électrique — Electric chandelier

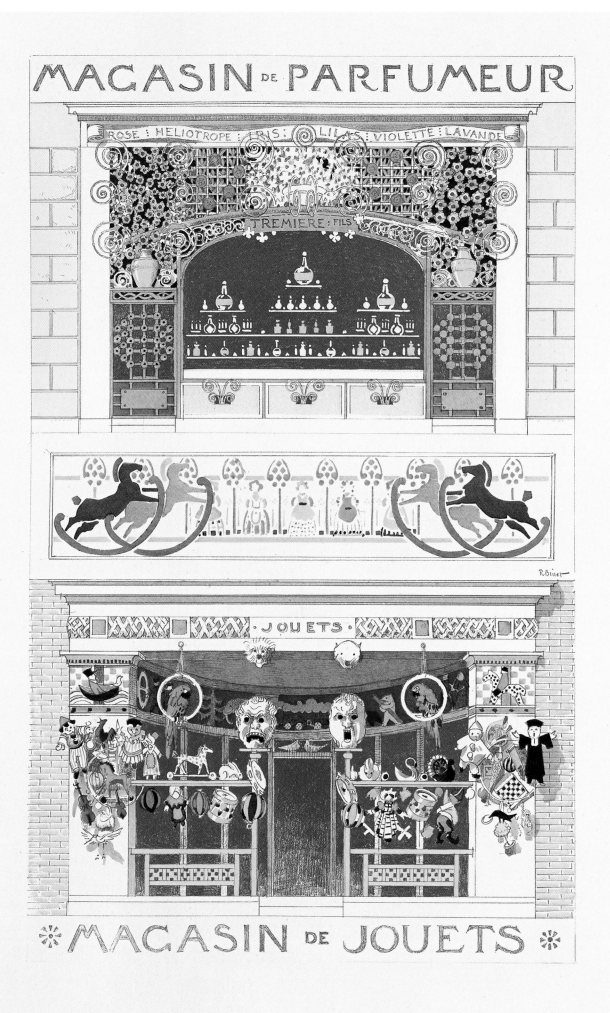

Magasin de parfumeur / Magasin de jouets — Perfumery, Toy shop

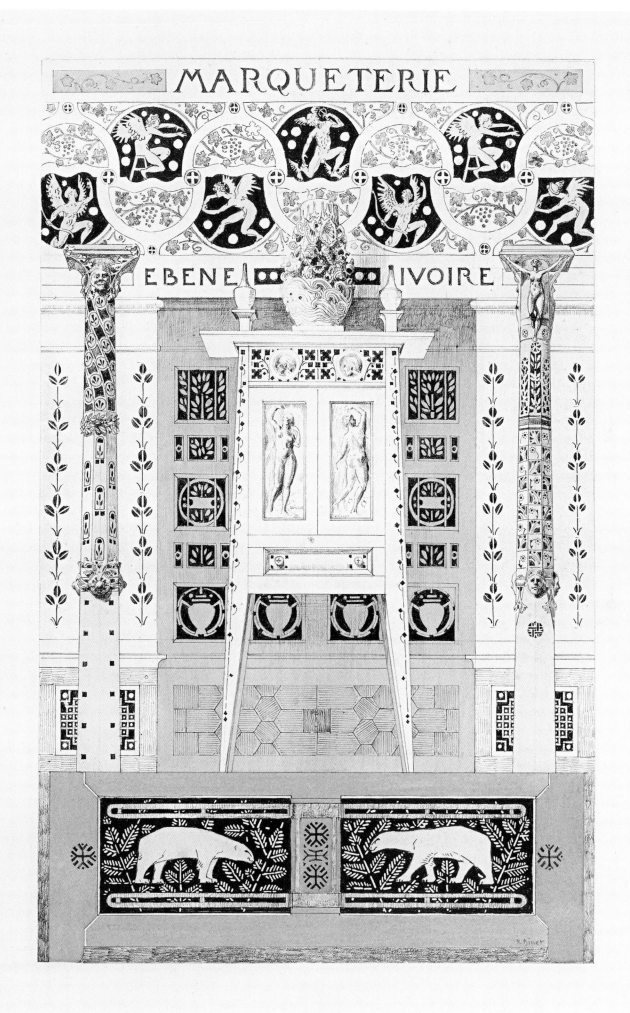

Marqueterie — Marquetry

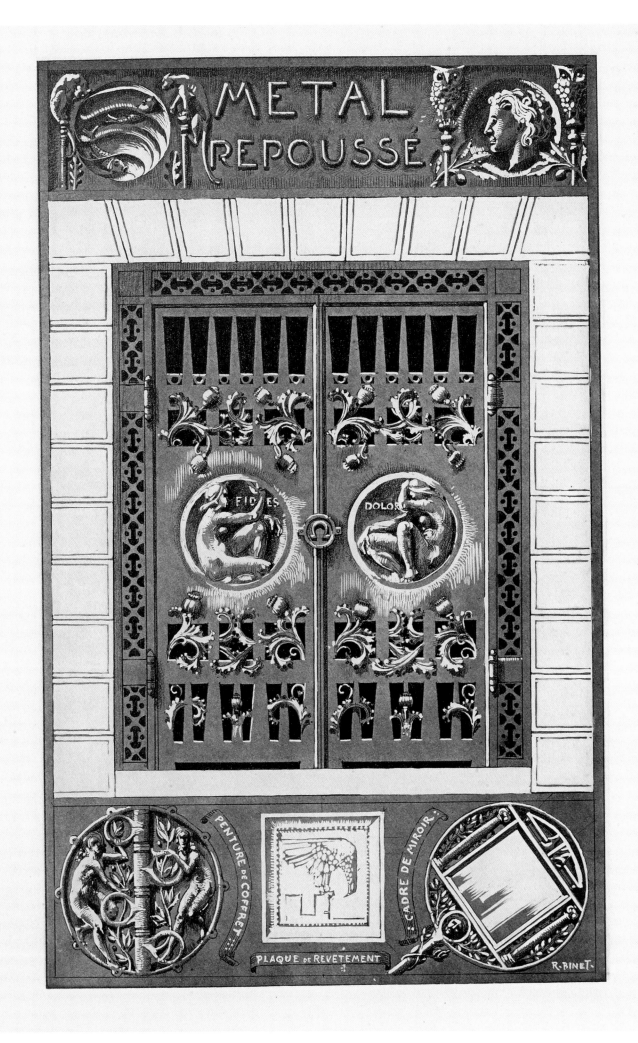

Métal repoussé – Repoussé metalwork

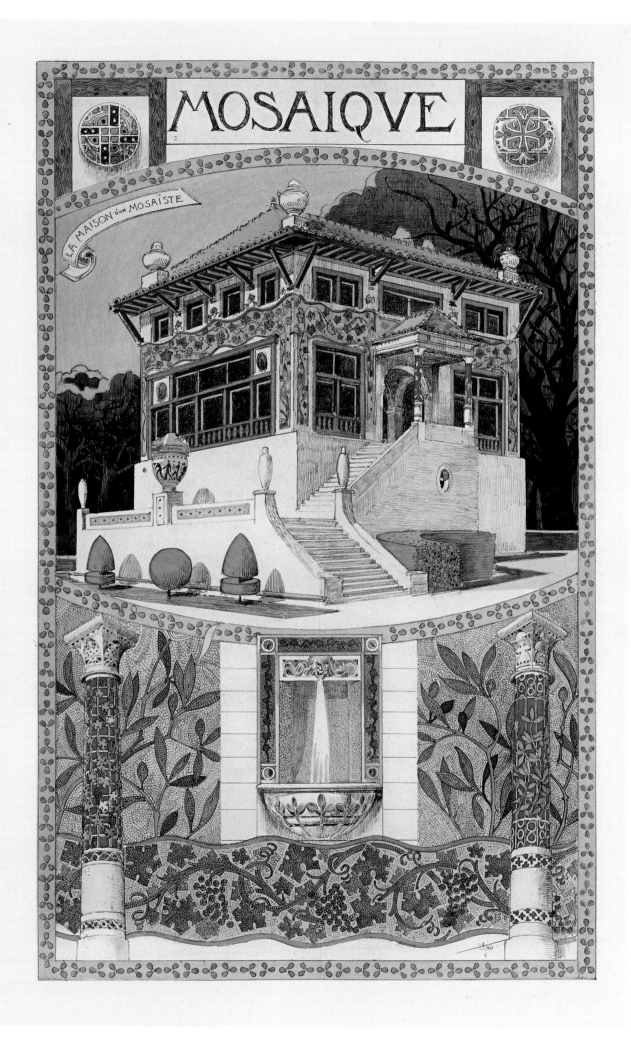

Mosaïque — Mosaic

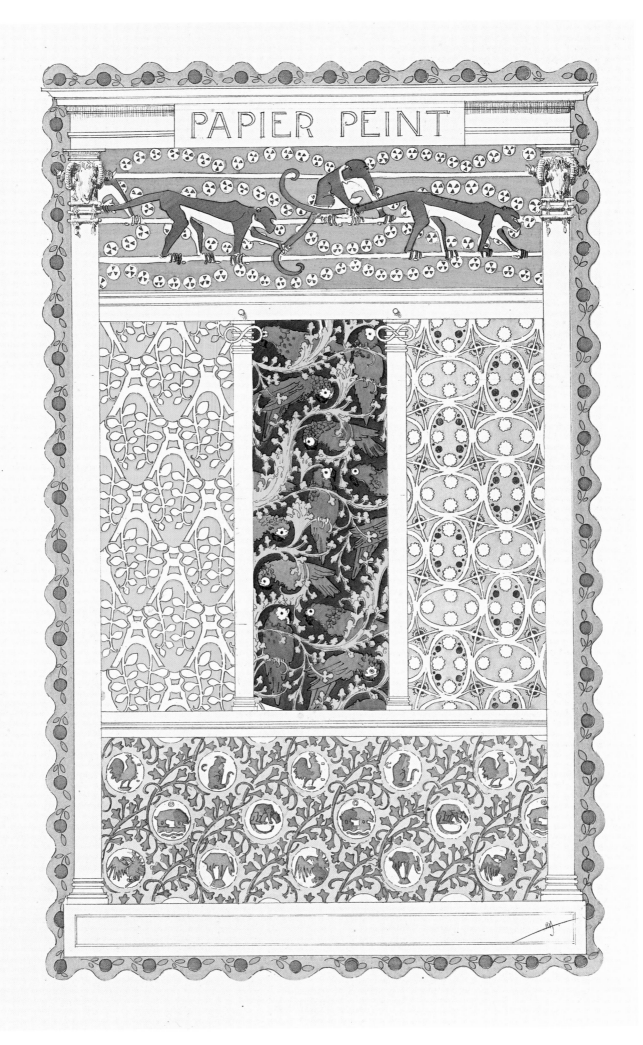

Papier peint — Wall paper

Pied de mat — Mast plinth

Pentures — Ornamental hinges

Plafond — Ceiling

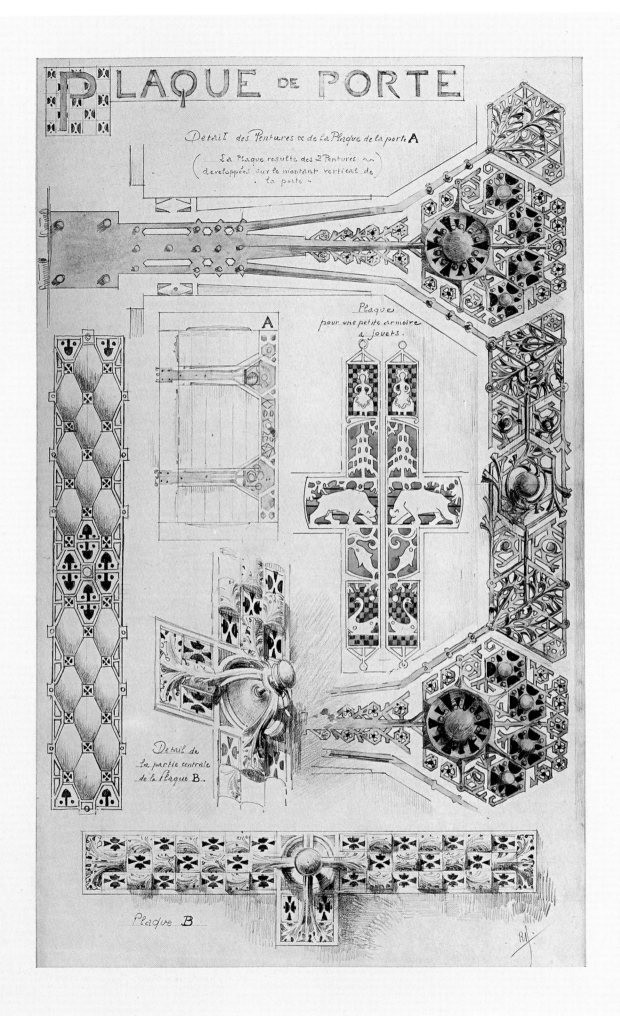

Plaque de porte — Door plate

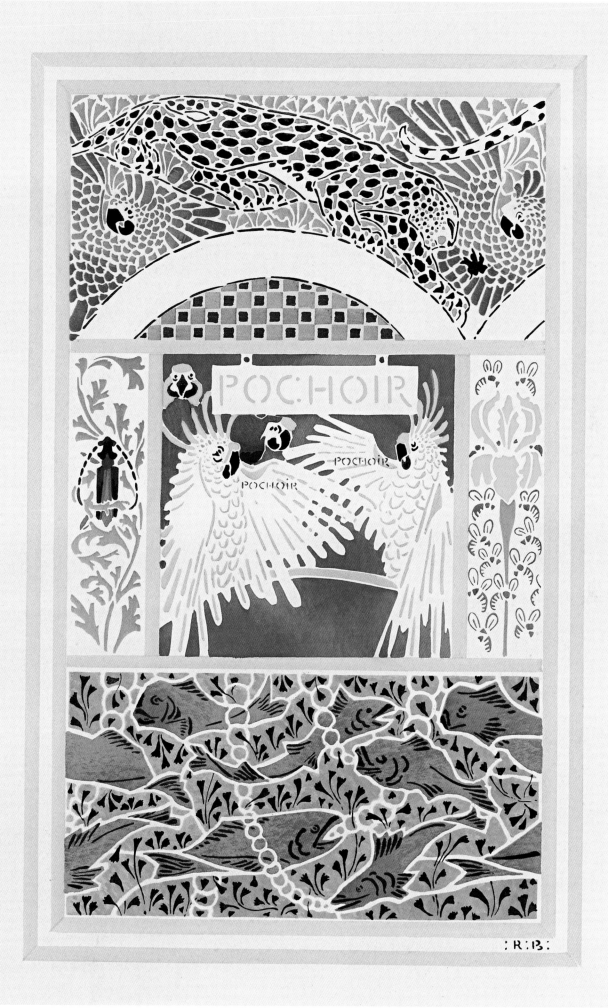

Pochoir — Stencil

Porche — Porch

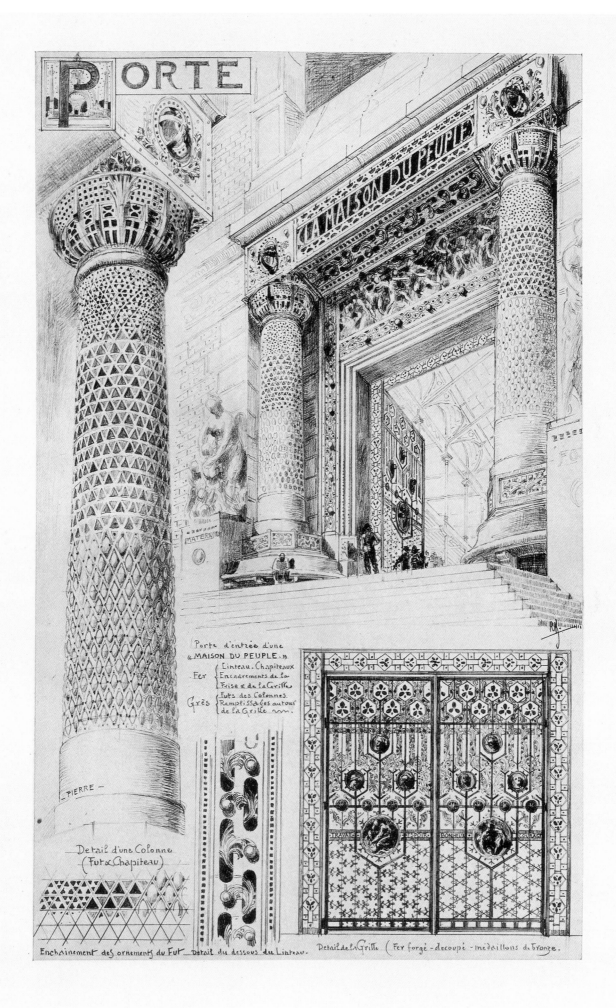

PORTE

LA MAISON DU PEUPLE

Porte d'entrée d'une
« MAISON DU PEUPLE. »

Fer Linteau. Chapiteaux
 Encadrements de la
 Frise et de la Grille

Grès Futs des Colonnes
 Remplissages autour
 de la Grille.

PIERRE —

Detail d'une Colonne
(Fut & Chapiteau)

Enchainement des ornements du Fut — Detail du dessous du Linteau. Detail de la Grille (Fer forgé - decoupé - medaillons de bronze.

Porte — Entrance

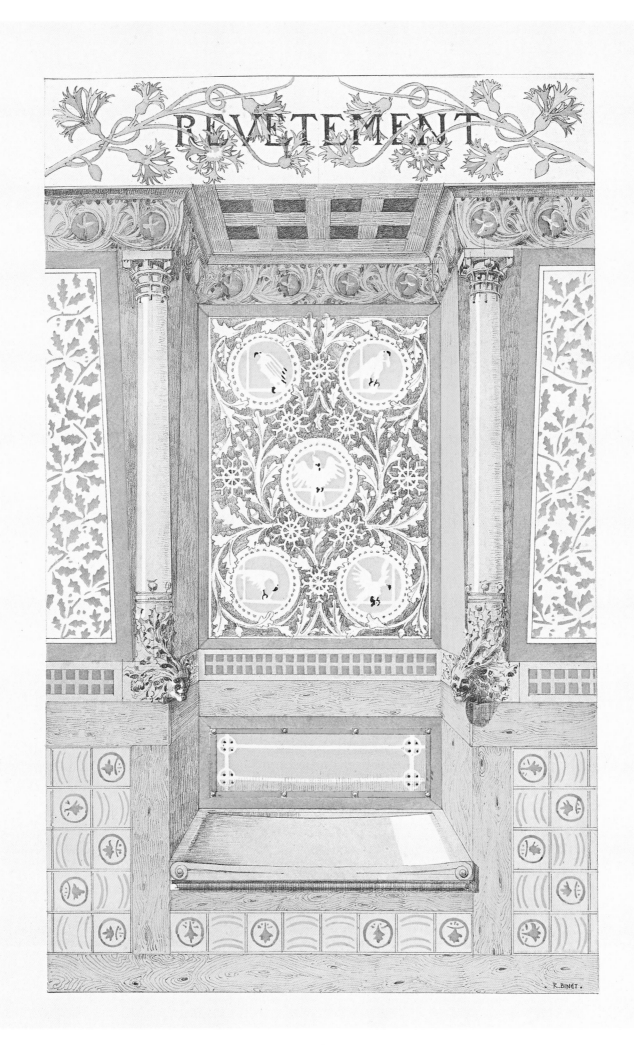

Revêtement — Surface ornament

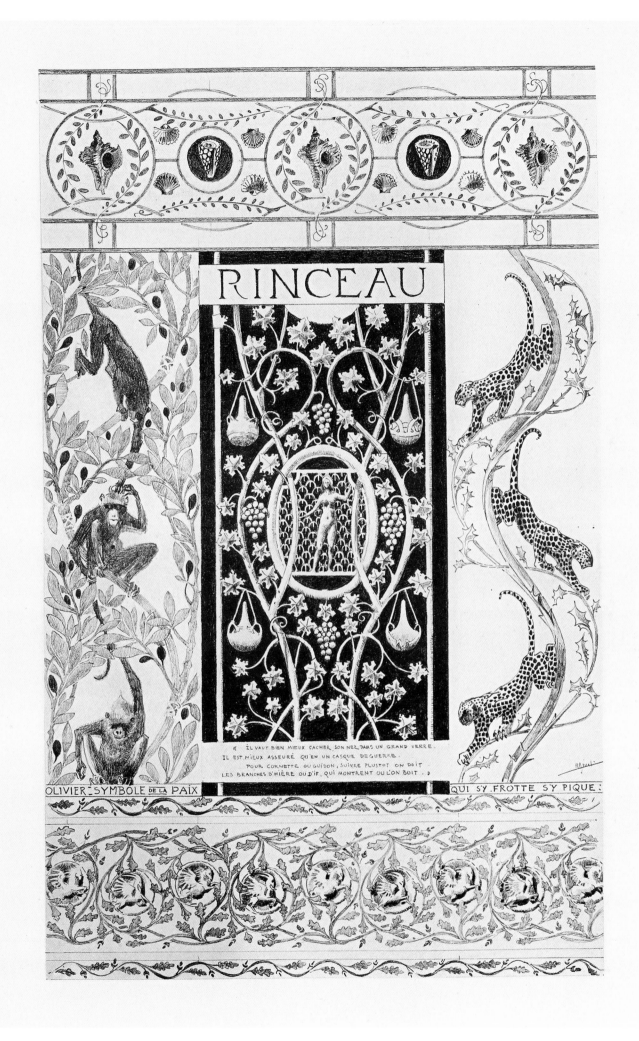

Rinceau — Foliage

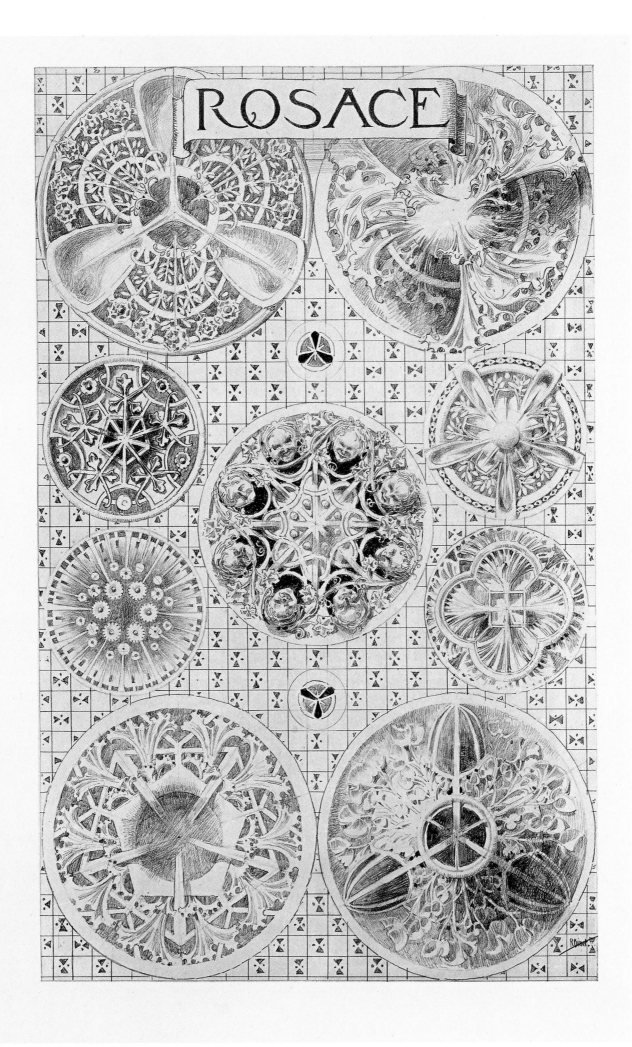

Rosace — Rosette, Rose work

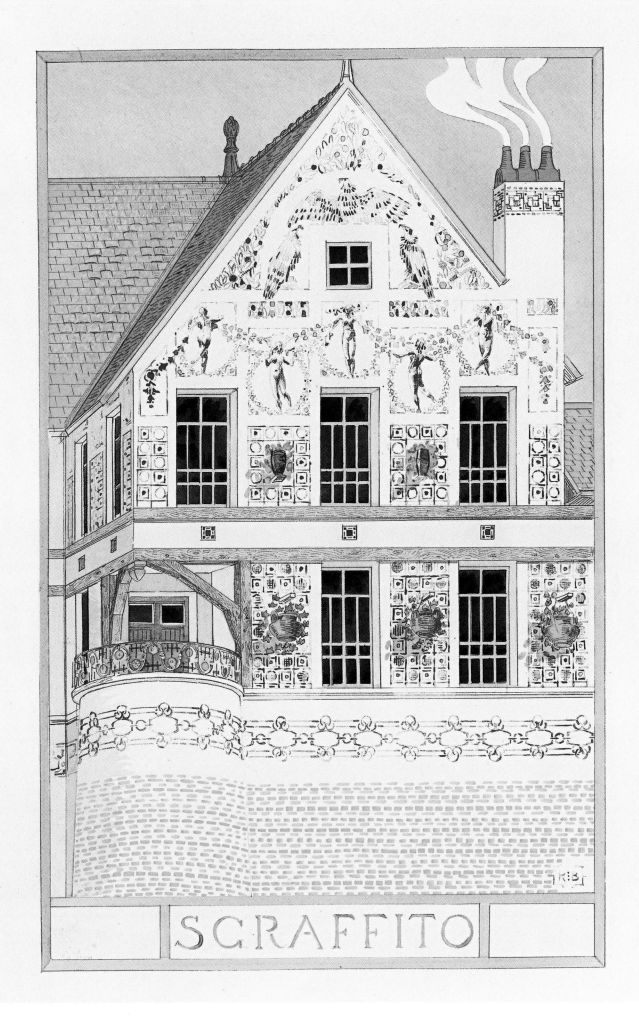

Sgraffito — Sgraffito

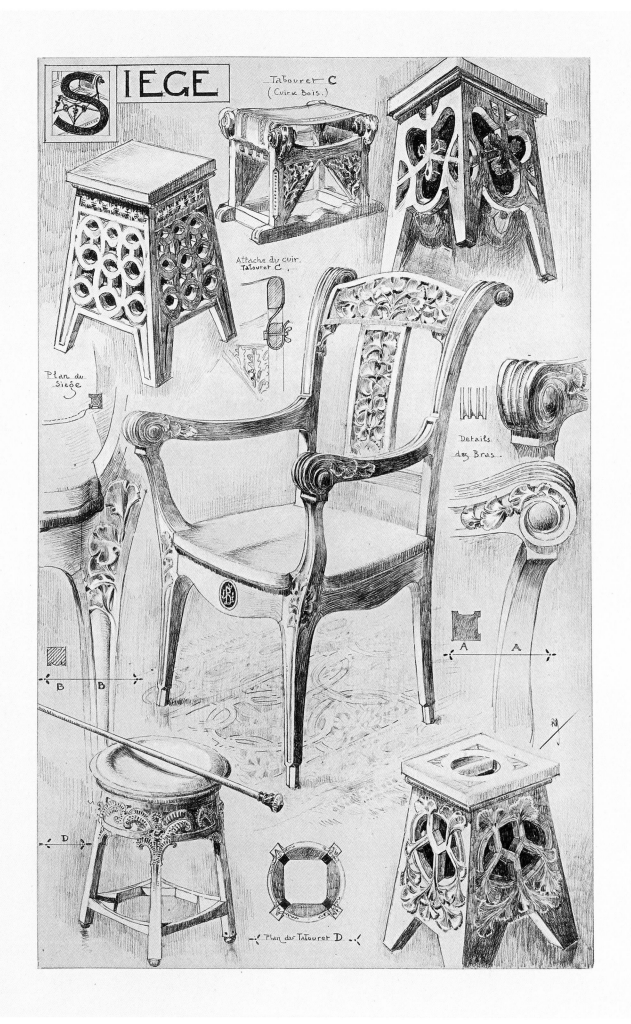

Siège — Seat

SOCLE

Socle en pierre

Socle en Plomb

SOCLE: Marbre Blanc
VASE: Étain.

STATUETTE: BRONZE
SOCLE ET CORNICHE:
MARBRE BLANC.
FEUILLAGES: BRONZE
DORÉ

Socle — Plinth

Tapis — Carpet

Tapisserie, Point compté — Tapestry, Cross stitch

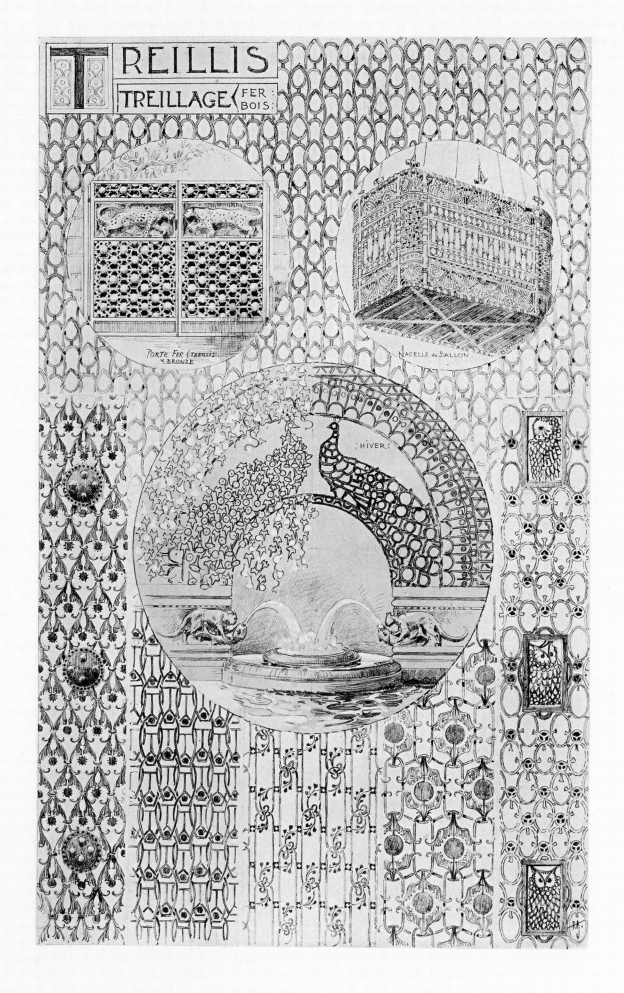

Treillis — Trellis

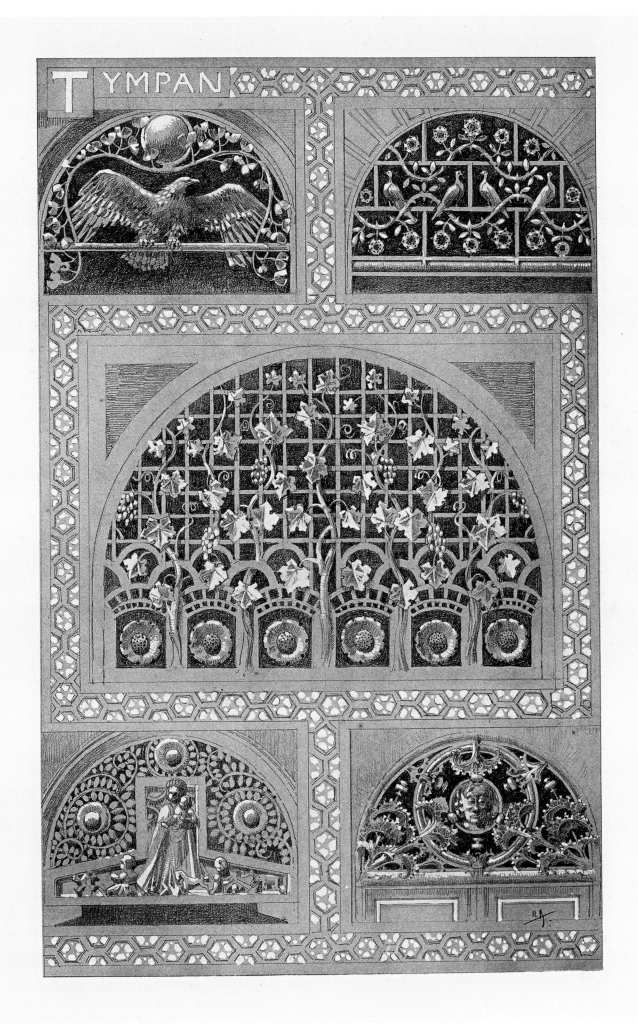

Tympan — Tympanum

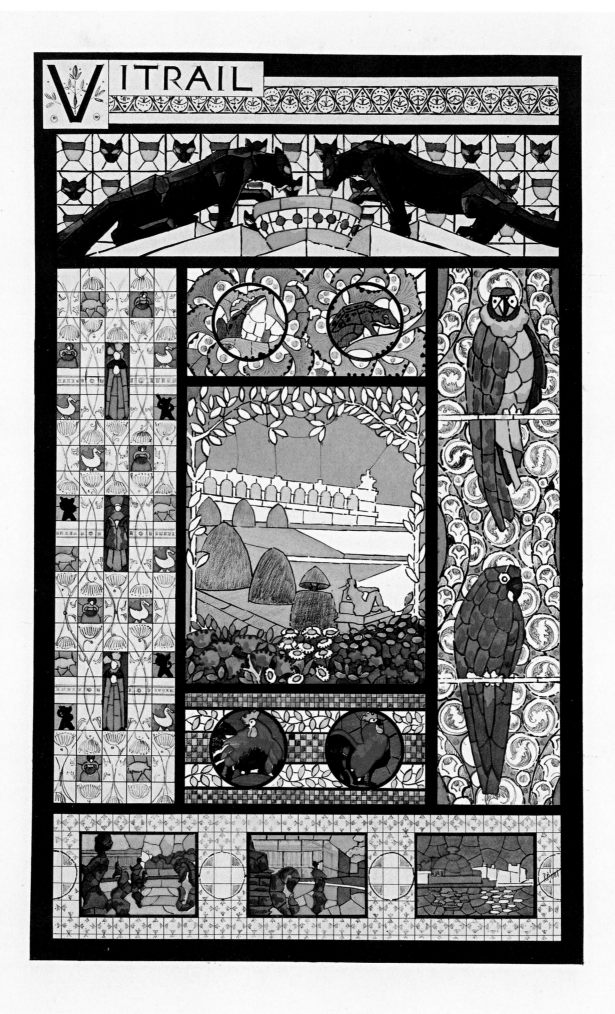

Vitrail — Stained glass

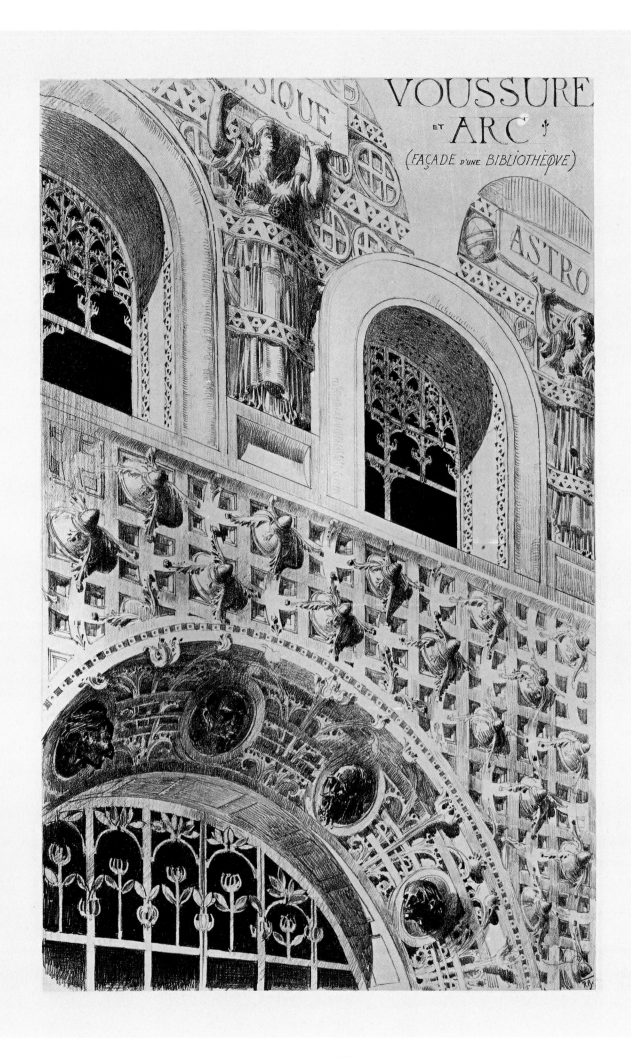

Voussure et arc — Vaulting and arch

Picture credits

Cambridge University Art & Architecture Library (Collection of the Faculty of
Architecture and History of Art Library, Cambridge): page 25, bottom
CEREP-Musées de Sens: page 24
Hessische Landesbibliothek Wiesbaden: page 9
Klassik Stiftung Weimar, Herzogin Anna Amalia Bibliothek, Sig. Arch 12[d]: page 6
Universitätsbibliothek Leipzig: page 25, top

The publisher would like to thank the Ernst Haeckel Haus in Jena for their
cooperation and loan of original documents.

Cover: Details taken from the plates Agrafe, *Lustre électrique and Pochoir*
Page 1: Motif taken from plate *Carrelage*
Frontispiece: Detail taken from the plate *Mosaïque*
Pages 4/5: Collage from the plates *Décor champêtre, Pochoir* and *Papier peint*

The Library of Congress number: 2006939111
British Library Cataloguing-in-Publication Data: a catalogue record for this book
is available from the British Library. The Deutsche Bibliothek holds a record of this
publication in the Deutsche Nationalbibliografie; detailed bibliographical data
can be found under: http://dnb.ddb.de

© Prestel Verlag, Munich · Berlin · London · New York, 2007

Prestel Verlag
Königinstrasse 9
80539 Munich
Tel. +49 (89) 38 17 09-0
Fax +49 (89) 38 17 09-35

Prestel Publishing Ltd.
4, Bloomsbury Place
London WC1A 2QA
Tel. +44 (0) 20 7323-5004
Fax +44 (0) 20 7636-8004

Prestel Publishing
900 Broadway. Suite 603
New York, N.Y. 10003
Tel. +1 (212) 995-2720
Fax +1 (212) 995-2733

www.prestel.com

Translation of Olaf Breidbach's essay from German by Paul Aston
Editorial direction by Anne Schroer
Copy-edited by Reegan Finger and Christopher Wynne
Design by Ilja Sallacz, Agentur Liquid, Augsburg
Layout and production by Andrea Mogwitz, Munich
Origination by ReproLine mediateam, Munich
Printed and bound by Passavia Druckservice, Passau
Printed in Germany on acid-free paper

ISBN 978-3-7913-3784-5